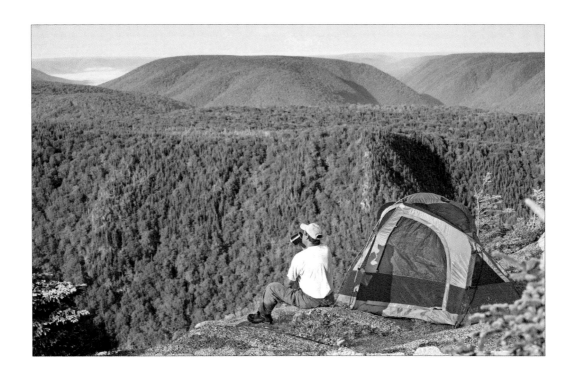

# Wild Nova Scotia

Photography by Len Wagg

Text by Bob Bancroft

PROTECTED WILDERNESS AREAS AND CANADIAN HERITAGE RIVERS, AND OTHER NATURE SITES

NIMBUS
PUBLISHING

Nimbus Publishing Limited
PO Box 9166
Halifax, NS    B3K 5M8
(902) 455-4286

Printed and bound in Singapore

Design: Troy Cole — Envision Graphic Design

Library and Archives Canada Cataloguing in Publication

Wagg, Len
Wild Nova Scotia / Len Wagg.

ISBN 10: 1-55109-613-7    ISBN 13: 978-1-55109-613-1

1. Wilderness areas–Nova Scotia–Pictorial works.
2. Natural history–Nova Scotia–Pictorial works.
3. Nova Scotia–Pictorial works.
4. Nature photography–Nova Scotia.  I. Title.

FC2312.W338 2007      508.716022'2      C2007-900077-0

We acknowledge the financial support of the Government of Canada through
the Book Publishing Industry Development Program (BPIDP) and the
Canada Council, and of the Province of Nova Scotia through the Depart-
ment of Tourism, Culture and Heritage for our publishing activities.

# Dedication

*Dedicated to those who educate us on the beauty and uniqueness
of our wilderness and those who work to protect it.*

# Acknowledgements

To my wife, Sandy, and children, Brett, Kiya, and Jodi, thank you for all of your support. I spent lots of time away from the house and chores and came back with piles of muddy camping gear and clothes.

This book would not have been possible without the help of my good buddy Jerry Lawson. Jerry hauled gear, planned routes, found photo angles, motivated me, and shared the laughs, mosquitoes, cold, rain, blisters, and sleepless nights during most of the trips it took me to create this book. I am truly a high-maintenance friend.

My love of the wilderness started while helping out with a local Scouting group. With Scouters Gerald Burgess, Doug Creelman, Marian Verboom Doucette, Deb LaBrech, and Laurel Ross, I have had the chance to help hundreds of youth discover the richness of camping and hiking in the wild, and we have all had lots of fun along the way.

We are lucky in this province to have a Protected Areas branch of the Department of the Environment, and the individuals that worked there are invaluable. I met with many and even hiked and flew with some while making this book, and collectively they share a vision and passion for the wilderness that is admirable. So, Chuck Sangster, John LeDuc, Peter Labor, Dave Williams, Lief Helmer, and Oliver Maass, thank you for your guidance, knowledge, and words of encouragement.

To Alan Jeffers and Exxon Mobil, thanks for getting me out to Sable Island to capture a truly magnificent part of our province. Also thanks to Zoe Lucas, who showed me around.

The generous support of Communications Nova Scotia made this book possible, and I am grateful.

Bob Guscott, friend and naturalist, pinpointed many locations for photos and continues to try to teach me what type of tree "that is." He, Bruce and Elaine Evans, and Sandy Wagg came out on a few trips to help out with the project. Thanks to both.

Pilot Rob Francis once again took time from his family and job to fly me around areas of the province, and Department of Natural Resources pilot Dave Farrell showed me why helicopter pilots get better pictures!

Jenny Ryon from the Canadian Centre For Wolf Research helped me to understand this incredible animal, now gone from this province but living at the centre for twenty years.

Bob Bancroft has a passion for the environment and a deep understanding of our Wilderness Areas, and he has shared his enthusiasm and knowledge with all of us in his writing for this book. Thank you very much for your valuable contribution, Bob.

Sandra McIntyre and Heather Bryan from Nimbus helped guide this project from the start; thanks to Penelope Jackson for the great word herding. They are very patient and talented people.

The GPS points in the captions (colour coordinated with the map legend) were collected along the way, and due to plane movement, steep gullies, and forest canopy cover, should be used as a guide, not as gospel. Any errors and omissions in this book are mine. For comments or prints, please visit www.lenwagg.ca.

**TITLE PAGE** || *CAPE CLEAR VIEWING SUGARLOAF*, Sugarloaf Mountain —
*(WA) NORTH 46 28.334 WEST 60 53.551*

# Preface

My tent shakes as the wind whips its minus-thirty-degree chill across the bluff in the Gabarus Wilderness Area on the south shore of Cape Breton Island. I twist and turn in the tent, trying to find a warm spot in the arctic sleeping bag, the tent occasionally blowing down into my face. I pull my balaclava closer to my face, the ice forming around areas where my breath has frozen on it. Rethinking my strategy of putting the tent in the open so that the early morning sun would bathe it in light and make for a good photograph, I fall into a fitful sleep. The next morning, as the single-burner stove works to heat up our coffee, I walk around the area and find in the snow moose, coyote, and hare tracks that were not there the night before.

Later that week, in North River Canyon, the tracks of predator and prey intermingle as the circle of life plays out. Standing on the shores of the river I see a curious sight—what look like otter tracks leading out of the river and up to the top of a snowbank, and then a slide that returns back to the river. It's not one set of tracks but many, like the tracks of kids racing back to the top of a toboggan hill to whip down again.

Making camp in February along the Liscomb River, my body is chilled as the sun goes down. The campfire burns in the darkness, but it seems to generate more light than heat. My buddy Jerry Lawson, who has accompanied me on most of my adventures, sets up the stove and boils the water for our nightly coffee with a good strong shot of Baileys. We talk about the day, how many kilometres we covered and photographs we took. The conversation always drifts to our amazement at how the people who were first on this land survived—First Nations people who travelled the rivers and forests and the first settlers who cleared the land and spent the cold winters wondering if spring would ever come. And all without Baileys.

Spring does come, and with it the black flies that fill nostrils, eyes, and ears. I don't use fly spray; it can get on my lenses and camera. Instead, I spend a weekend in the Boggy Lake wilderness area, with black flies on the water, in my hair, on my fingers and in my food and coffee. I stop hiking and feel the flies land on my neck and, somehow, inside my shirt until they make me want to rip off my clothes and jump in the water. All subsequent buggy days pale in comparison.

As the days go on, the wildflowers start to bloom and, travelling in Kempton near Gully Lake, naturalist Bob Guscott and I wait in the early morning for the flowers to bloom—Bloodroot, Dutchman's Breeches, mayflowers and trilliums all seem to unfold before our eyes as the sun takes over the forest floor. Their days are numbered, as the leaves beginning to grow above block out the sunlight.

The warm-weather trips are fun, but staying in a tent and sleeping bag in the middle of winter is definitely not everyone's idea of a good time. Still, I have been making these trips for good reason: to photograph the thirty-three Wilderness Areas in Nova Scotia throughout the four seasons. These areas, protected from mining, logging, and motorized vehicles, are the cornerstone of a project designed

to conserve valuable land for generations to come. Environmentally harmful acts such as clearcutting entire forests, building huge houses on the coast and on inland lakes and rivers, and driving off-road vehicles through areas of the province once home only to native species are forever changing our province. The preservation of the Wilderness Areas is an attempt to offset the damage done by humans.

There are no marked entrances to the Wilderness Areas. A few have hiking trails within them, but for the most part you need a map, a compass, and GPS to go deep into the wild. Some of the areas are best travelled by canoe or kayak, some by foot. Some areas include historical roads, and bringing old maps of long-vanished communities has proven invaluable.

Often hiking is made easier by following all-terrain vehicle (ATV) trails—a mixed blessing. Although no motorized vehicles are allowed in Wilderness Areas, almost every area bears the scars of ATV use. Many bogs are destroyed by a maze of tracks, smaller trees are levelled into the ground, and there are always beer cans and plastic oil jugs littering the devastation. Off-road vehicles are and will continue to be a huge issue for those who use and oversee protected areas. Some people have a sense of ownership of the land—often their families have fished and hunted there for generations—and they feel they can use ATVs if they want; some feel that their ability to move through the wild quickly can help them identify problems and alert authorities. The debate rages on, but the reality is that this land belongs to all Nova Scotians, all Canadians. It is protected so that generations can enjoy it without the danger of it being lost to a few who refuse to accept that they, not their vehicles, are welcome in the protected wilderness.

Perhaps the biggest contradiction in government policy is that logging is allowed in game reserves. Searching out the Alder Grounds Wilderness area, which borders the Liscomb Game Sanctuary, I had to navigate through a wasteland of downed trees, dug-up dirt roads, and debris from the deforesta-tion of the area. So there's a Game Sanctuary, where you can log but not hunt, next to a Wilderness Area, where you can hunt but not log. Essentially, there is no safe habitat for wildlife in these circumstances.

When I started to shoot the photographs for this book, I tried to learn as much about the areas I visited as possible, to help me capture the essence of each place. I researched what types of trees grew in an area, what its geological makeup was, what river and bog system it held. But as I began my travels through these areas, the research became relatively unimportant. I could actually feel the changes in the land—I could sense transitions in the forests I hiked through, the ground I walked on. The essence of each place can't be itemized and categorized; the land speaks for itself. Paddle a kayak through the maze of giant granite boulders on the Roseway River, watch the fingers of light fill in the darkness of the Margaree Wilderness Areas canyons as the sun rises, or listen to a young barred owl fly overhead in the Eigg Mountain–James River area, and the significance of these protected areas and their importance as a natural legacy becomes incredibly clear.

Years ago, I covered the famine in Ethiopia as part of my work as a photojournalist for the *Chronicle Herald*. One evening, in a tiny village on the border of Somalia, I sat and drank a beer with an Ethiopian doctor. We talked about the crisis his country was facing, and the tragedies he witnessed every day. Eventually I started looking for familiar constellations in the night sky. He saw me looking and said, "It's the same sky, but a different world." I revisit that moment often when I see the big night sky. In September 2006, Jerry and I arrived in the Middle River Wilderness Area. We set up camp and sat in silence out in a field with a beer, watching shooting stars race across the sky. The words of the doctor from years ago came back to me. I realized that when I'm in a Wilderness Area, I'm looking at the same sky as people in Halifax or Sydney or Truro, but I'm in a different world.

—*Len Wagg*

# *Introduction*

I've admired his work in the *Chronicle Herald* newspaper for years, but Len Wagg has served up a particularly delicious concoction with the photographic art in this book. For many folks, as for Len, wilderness is fodder for the mind, body, and soul. Human spirits soar into these infinite, changing landscapes woven of sky, forest, rock, earth, and water. Free from the trappings and scars of "civilization," wilderness can wake up senses numbed by years of pavement, concrete, and glass, incessant noise and noxious fumes. Sights, sounds, smells and textures suddenly abound, and our brains cannot ignore the new stimuli. At the same time, a feeling of seclusion gradually spreads its mantle over our psyche, filling our minds with a sense of peace.

This book is an invitation to reflect upon Nova Scotia's wild places. Take warning! Such contemplation can make one feel joy, inspiration and wonder for which there is no known cure. For some vulnerable folks, direct wilderness experience can cause a transformation of personal perspectives, helping to forge a renewed, more vital personal vision and identity. Identification with nature can cause changes in personal values and actions, redefining one's sense of self. A lifetime of studying ecology, travelling in wilderness, and contemplating what I've learned has significantly altered my own personal identity.

Living in the Yukon as a child, I gradually acquired the skills to hike alone and to travel by canoe and kayak. I learned to survive in wilderness and eventually preferred it to concrete and glass. When I was alone without a gun,

grizzly bears became the dominant species. I was in their food chain. Back in Nova Scotia, moose or black bears protecting their young can evoke similar feelings of humility. We share this part of the earth with many creatures who have needs and require wild habitats.

The physical aspects of this province distinguish it from continental North America. Nova Scotia's 55,284 square kilometres of peninsular land is almost surrounded by the Atlantic Ocean, connected by a narrow sliver of land called the Chignecto Isthmus. This near-island condition fosters a sense of timelessness that permeates the atmosphere and has yet to be broken by four hundred years of European occupation. The influence of the sea is powerful and pervasive as it rises, swells and recedes along more than 7,500 kilometres of undulating coastline. With a climate moderated by the warm, offshore flow of the Gulf Stream current, Nova Scotia rarely exhibits the extremes of hot and cold weather common at similar latitudes in North America's interior.

The Mi'kmaq were people of the forest when they welcomed Europeans and helped them survive their first winters in Nova Scotia. The Mi'kmaq depended on the land for survival and had great respect for what the Earth provided. At that time the forests formed a verdant green mantle over much of the land. Dominant softwood trees included hemlock, white pine, and red spruce that commonly lived for two hundred to four hundred years. Hardwoods like yellow birch, sugar maple, white ash, red oak, white elm, and beech were more common

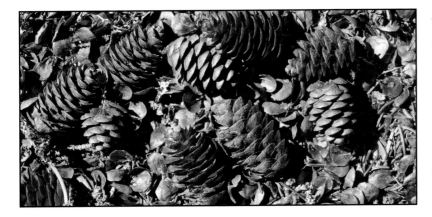

While engaged in a botanical survey of the region, I decided to get a look at that forest. The last of the great oaks were being clearcut when I arrived. A history of mining, forest cutting, and other real estate activities, combined with evolving technologies that have more all-terrain vehicles, snowmobiles and four wheel drives pushing into its last bastions have put wilderness in a perilous position.

That course altered somewhat after the Rio World Summit on the environment. In 1992 the Nova Scotian government and other governments across Canada committed to setting aside a network of protected natural areas by the year 2000 to preserve and represent their unique landscapes. In early 1997 the province released a Protected Areas Strategy. That strategy evolved to include eighty different representative natural landscapes. Thirty-one Crown land areas were identified as candidates for protection. They became the first wild places to be set aside under the Wilderness Areas Protection Act when it was passed in December 1998. Two more sites were added in 2005. To date this process has protected roughly a third of the eighty representative landscapes. It has become obvious that provincial Crown land and federally owned National Park lands in themselves cannot provide the necessary wilderness area representation in Nova Scotia.

than they are now. These trees also grew to gigantic proportions compared to the forests of today, which are often harvested before they become elders.

Today, half of the forested part of the province is owned by small private landholders. Another twenty percent is held by large private landholders, leaving less than thirty percent as provincial Crown land. Forested Crown land is usually administered by the Nova Scotia Department of Natural Resources, which follows a tradition of leasing or contracting wood harvests to various forestry companies. This practice is being questioned by organized environmental groups who suggest that the Department of Natural Resources is mismanaging public (Crown) land by allowing clearcut harvests for private profit. These groups consider the Crown holdings to have other uses and intrinsic values, particularly when the elimination of woodlands results in the destruction of terrestrial and aquatic wildlife habitats and the displacement of wildlife. Forest ecosystem recovery from clearcut harvests can take centuries. At the present time less than one percent of the original forests remain.

Technology in recent times has taken on a significant role in exposing and suddenly laying wilderness bare. Areas not afforded some protected status can change abruptly. Thirty years ago I read about an unusual red oak stand beside Quinan Lake that had been identified under an international biological program.

To complete this task, the seventy percent of the province that is privately owned must be tapped. Acquisition is normally very expensive for governments or conservation groups. An alternative involves writing conservation easements, where landowners enter into partnership with a conservation organization to reach an agreement regarding how to manage the land, and continue with this arrangement, with adjustments, long into the future. National environmental organizations that are actively promoting wilderness issues include the Canadian Parks and Wilderness Society, Canadian Wildlife Federation, Nature Canada, the Sierra Club of Canada, and the World Wildlife Fund (Canada).

A number of national organizations have been reaching out in recent years to acquire, conserve and protect private lands in Nova Scotia. The Nature Conservancy of Canada has been instrumental in acquiring unique properties with

**ABOVE** || *PINE CONES*, Kellys Mountain — *NORTH 46 12.078 WEST 60 33.157*

**FACING PAGE** || *FORMATION FLIGHT*, Boggy Lake — *(WA) NORTH 45 06.306 WEST 62 17.125*

with important habitats by means of partnerships, conservation agreements, and purchase of private land in Nova Scotia. Ducks Unlimited Canada has a remarkable history of working with governments and private landowners to restore degraded wetlands in Nova Scotia and elsewhere. Land development across Canada has drained a combined wetland area more than three and a half times the size of Nova Scotia. This has transpired mostly for agricultural purposes. A prime example is the loss of most of Nova Scotia's productive salt marshes. Their conversion to farmland was accomplished by the construction of dykes with aboiteaux to facilitate drainage during low tides.

Within Nova Scotia, a host of local organizations strive to further the cause of wilderness preservation. The Nova Scotia Nature Trust (NSNT), for example, is a non-governmental organization that has been working since 1994 to help preserve the province's natural heritage through the protection of ecologically significant private properties. Working with obstacles like tax rules that inhibit land donations, the NSNT needs and deserves the support of more private landowners.

It is fortunate that Nova Scotia's long history of settlement has been somewhat offset by its relatively sparse human population, and confounded by diverse landscapes as well as ownership patterns. Wild places can still be found

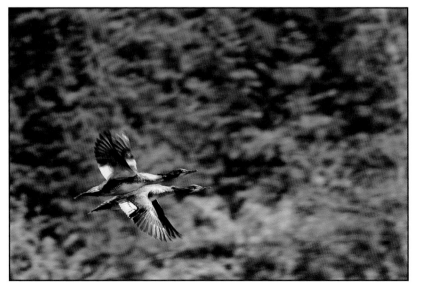

around the province, and the forces of wilderness are often quick to return on previously developed land that humans have abandoned.

Many mainland folks consider southwestern Nova Scotia's Kejimkujik National Park and the adjacent Tobeatic Wilderness and Tobeatic Wildlife Management Areas to be their premier mega-wilderness destinations. One can paddle and portage these lakes and rivers and camp under the stars for a week or more without seeing another human being. Within those landscapes flows the Shelburne River, a federally designated Canadian Heritage River. Spring or autumn canoe trips in such designated wilderness areas become cherished memories. Paddling Lake Rossignol to reach the Lake Rossignol Wilderness Area is exciting when the wind rises and one begins to negotiate metre-high waves. At the other end of the province, Cape Breton Highlands National Park is a world-renowned wilderness. The Highlands also form the headwaters of the Margaree River, another Canadian Heritage River.

The thirty-three Wilderness Areas have opened up a host of new outdoor venues on Crown land for nature lovers. Each site was chosen for its unique natural and geological features. Some locales, like McGill Lake, are relatively small and can be easily reached by automobile. Launching a canoe there, I was soon watching a beaver build a lodge over a rock crevice along the lake's sheltered shore.

Effortless access, however, can result in too many human visitors and a plundering of cherished wild places. On the other hand, the Canso Coastal Barrens can only be accessed by hiking, sea kayaking, or better still, a combination of both. One can paddle, hike, and camp for a week and experience only a small portion of what this wild end of Nova Scotia has to offer. Another remote location is the Middle River-Framboise Wilderness Area. I carried a canoe for two and a half hours while navigating by means of a compass to reach Big Island Lake.

Voracious hordes of mosquitoes, blackflies, deer flies, and horseflies can overwhelm your otherwise pleasant wilderness travel. When I first set out with compass and map on a four-hour trek to reach the Trout Brook Wilderness Area east of Lake Ainslie, a blood-thirsty battalion of winged warriors soon turned me back. I returned for a second attempt in the cool air of late summer and experienced a relatively bug-free hike.

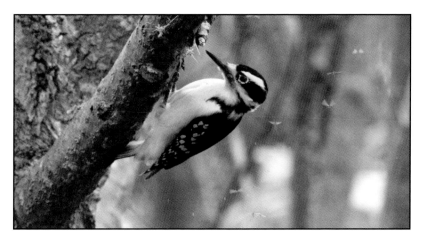

Safety and planning are critical to enjoyable wilderness travel. Access points to these wilderness areas can usually be found in the 1:150,000 scale detail of the Nova Scotia Atlas, which shows the contour lines—marking hills, valleys, and other geographical features—so helpful when travelling by compass. For more detailed maps, consider purchasing a 1:50,000 scale map for the particular area. The Protected Areas Division of the province's Department of Environment and Labour also has valuable maps and information. The weather in Nova Scotia is often changeable, making lightweight waterproof clothing a smart addition on any wilderness trek—irrespective of the forecast. Whenever one plies the Atlantic in small craft, it's wise to travel with some experienced companions, watch the weather, and know your limits.

The physical elements of nature are but one part of the wilderness experience. Something primal about it triggers subconscious emotions, stirs our senses and resonates within our souls. Wild places have inspired generations. Thomas Moran's art documenting the landscapes, geysers, and hot springs of Yellowstone motivated an indifferent US Congress to establish the land as that country's first national park in 1872. In Canada the Group of Seven were a strong influence in the creation of Ontario's Algonquin Park.

A broad spectrum of thinking and philosophies exists about wilderness and our environment. North Americans who helped to shape my nature and wilderness perspectives with their writings and ethics include Henry David Thoreau, John Muir, Rachel Carson and Aldo Leopold. The issue of preservation or conservation is one they have been grappling with for decades. Preservationists like Muir see humans as just one of many species and seek to preserve wild land for its own sake. Conservationists are more human-oriented, conceding intellectually that nature is a resource to be both used and preserved. The latter rely on wisdom and careful stewardship to achieve a balance. Both sides profess a love of wilderness, but the ethics translate very differently. There is a need to forge a unified, consensual approach to stewardship that conserves resources for human use and recognizes the issue of economic welfare, while preserving and leaving what nature needs to survive as a whole.

The solitude of wilderness retreats often prompts serious reflection about one's life in relationship to nature. Many folks find themselves grappling with their sense of personal identity and reasons for existence. Some use contemplation of the wild as a means to reconstruct their values and find their place in this world. Reconnecting with the natural world can serve to unlock one's personal confusion about life, and to create a psychological counterbalance for alternate, unavoidable lifestyles. Yet this link is in danger of being lost. New lives filled with computer screens and virtual realities have many young people exhibiting symptoms of a malady that Richard Louv calls "nature-deficit disorder" in his 2006 book *Last Child in the Woods*.

Back in the "rat race," I can calm my soul and feel connected simply by remembering a timeless moment during a canoe trip last September. As I watched from a west-facing shore, the sunset painted the lake's faint ripples with shades of purple, red, and gold, framed by shimmering blacks and liquid silvers. Silhouettes of two loons danced and their calls echoed over the water in the fading light.

Len Wagg has an artist's eye for capturing wild landscapes and wildlife portraits. These images will prompt the adventurous to seek out new wilderness.

ABOVE ‖ *DOWNY WOODPECKER,* Clattenburgh Brook — *(WA) NORTH 44 53.516 WEST 63 22.995*
FACING PAGE ‖ *BOG AND DRUMLIN,* Middle River–Framboise — *(WA) NORTH 45 45.401 WEST 60 32.102*

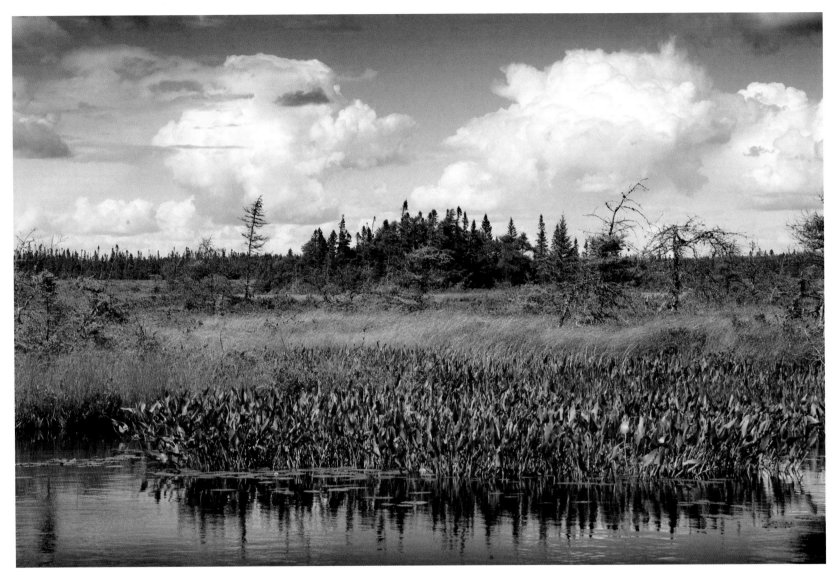

People who have spent years travelling the wild may find that his photographs evoke strong memories of other remote places. The call of the wild can be an intoxicating, even habit-forming, tonic, a state of mind compelling one to return. Spending time in nature can be a source of profound wisdom and personal happiness. May this book be an inspiration for you to visit, value and perhaps help save Nova Scotia's wilderness places.

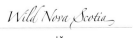

*Wild Nova Scotia*

# Wilderness Areas, Canadian Heritage Rivers, and Other Wilderness Sites in Nova Scotia

**50** Km

**N**

ATLANTIC

OCEAN

Bay of Fundy

Northumberland Strait

St. Georges Bay

Amherst
Pictou
Antigonish
Sydney
Parrsboro
Truro
Canso
Kentville
Stewiacke
Windsor
Dartmouth
Halifax
Digby
Bridgewater
Shelburne
Yarmouth

## Sites Legend

### Wilderness Areas (WA)

WA1 - Polletts Cove-Aspy Fault
WA2 - Margaree River
WA3 - Jim Campbells Barren
WA4 - French River
WA5 - Sugarloaf Mountain
WA6 - Middle River
WA7 - North River
WA8 - Trout Brook
WA9 - Middle River-Framboise
WA10 - Gabarus
WA11 - Scatarie Island
WA12 - Ogden Round Lake
WA13 - Bonnet Lake Barrens
WA14 - Canso Coastal Barrens
WA15 - Liscomb River
WA16 - The Big Bog
WA17 - Alder Grounds
WA18 - Boggy Lake
WA19 - Tangier Grand Lake
WA20 - White Lake
WA21 - Clattenburgh Brook
WA22 - Waverley-Salmon River
Long Lake
WA23 - Terence Bay
WA24 - Economy River
WA25 - Portapique River
WA26 - Cloud Lake
WA27 - McGill Lake
WA28 - Lake Rossignol
WA29 - Tobeatic
WA30 - Tidney River
WA31 - Bowers Meadows
WA32 - Eigg Mountain-James
River
WA33 - Gully Lake

### Canadian Heritage Rivers (CHR)

CHR1 - Margaree-Lake Ainslie
CHR2 - Shelburne River

### Other Sites (OS)

OS1 - Yellow Head
OS2 - Kellys Mountain
OS3 - Bornish Hill Nature Reserve
OS4 - Sable Island
OS5 - St Marys River
OS6 - Grand Lake
OS7 - Wellington
OS8 - Panuke Lake Nature Reserve
OS9 - Kejimkujik National Park
and Historic Site
OS10 - Lower Sixty Lake
OS11 - Cape Split
OS12 - Cape Chignecto Provincial Pa
OS13 - Cobequid Mountains
OS14 - Cobequid Bay
OS15 - Canadian Centre for Wolf
Research

## Legend

### Wilderness Areas

Wilderness Areas protect typical examples of Nova Scotia's natural landscapes, biological diversity, and wilderness recreation opportunities.

### Canadian Heritage Rivers

Canadian Heritage Rivers conserve and protect the best examples of Canada's river heritage.

### Other Sites

Other wilderness sites in Nova Scotia

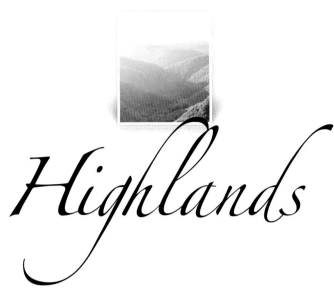

# Highlands

Northern Cape Breton Island is an ancient, towering block of metamorphic and granitic rocks called the Highlands. A billion years ago the earth's crust shifted in massive movements that deformed these rocks into the twisted shapes that can be seen today in cliff faces. Over time deep valleys were cut into these rocks by the running water of many streams. Larger waterways downstream include the Margaree, French, and North rivers. The spectacular North River waterfall is one of many that occur along the Highlands' edge.

The Highlands display many fracture zones in the earth's crust called faults. These are lines along which movement of the earth's plates occurred. The largest and most conspicuous fault in the Highlands is the Aspy fault. It runs south from Cape North for forty kilometres along a straight, spectacular escarpment, and eventually reappears on the south side of the Margaree Valley. Many rivers follow fault lines, but the Margaree Valley is unusual in having a broad intervale that extends into the Highlands. Here the forest has shade-tolerant hardwoods, like sugar maple and yellow birch. Their fallen leaves provide vital nutrients for the food chain that supports Atlantic salmon and sea-run speckled trout in the Margaree River.

The considerable depth of the Highland soils suggests that they were protected by a cover of ice that did not move during the last ice age. The forest of the Highlands is boreal, like the forests across northern Canada. They consist mainly of balsam fir, white birch, and white spruce. This forest differs from the remainder of Nova Scotia. The climate is influenced by high elevations and strong ocean winds. The Highlands receive a great amount of precipitation compared to the rest of Nova Scotia. Cold, long winters with four hundred centimetres of snow are followed by cool, short summers. Some locales have less than thirty frost-free days a year. Strong winds stunt tree growth along ridges and other exposed sites, including Jim Campbell's Barren, which features an unusual bog and barren complex.

Hiking the Highlands yields spectacular views as well as healthy cardiovascular exercise. Here one can see moose and snowshoe hare, and visit the last Nova Scotian stronghold of the lynx. Grey jays and the threatened Bicknell's thrush inhabit these forests. If wolves and cougar exist (the former were extirpated in the late 1800s, and the latter may have suffered the same fate. There have since been many sightings of both, but many biologists think there is insufficient evidence to confirm their presence in the province), this would be ideal habitat for them. Some white-tailed deer travel onto the Highlands each summer, but they move off the plateau in autumn to avoid the deep snows.

Spruce budworm attacked this boreal forest in the 1970s, killing spruce and fir trees en masse. Another budworm epidemic seems imminent now in the thirty-year-old forest. Pollets Cove–Aspy Fault contains a unique climax hardwood forest in a canyon, some coastal mountain barrens, and wetlands associated with undisturbed watersheds. (A climax forest is one that has evolved without major disturbance for hundreds, perhaps thousands of years.) The French River area includes a unique boreal kettle knob ecosystem (kettles are large depressions left in loose ground by a detached hunk of glacier ice that has since melted, and a knob is an isolated round hill or mountain), rare plants, and a climax balsam fir forest, as well as climax hardwood forests and a hemlock forest that is more than three hundred years old. Besides its spectacular waterfall, North River has hemlock forests, climax hardwood forests, and a unique large bedrock barren. Flowing into Lake Ainslie and the Margaree Canadian Heritage River, the Trout Brook has an old growth (a forest that has grown to a state where it changes little without disturbance) hardwood canyon ecosystem with a unique yellow birch and balsam fir forest. Where it empties into the lake, speckled trout find a cool summer refuge. Spectacular and wild, the Highlands' untamed spirit should be experienced.

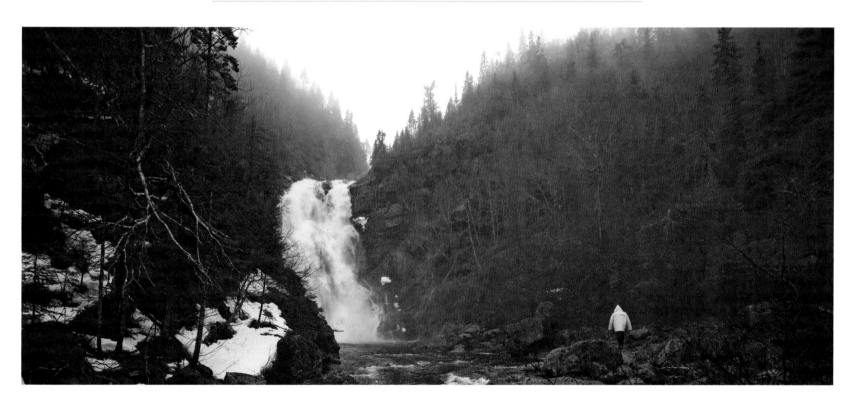

*Nova Scotia's highest waterfall*, North River — *(WA) North 46 22.216 West 60 41.770*

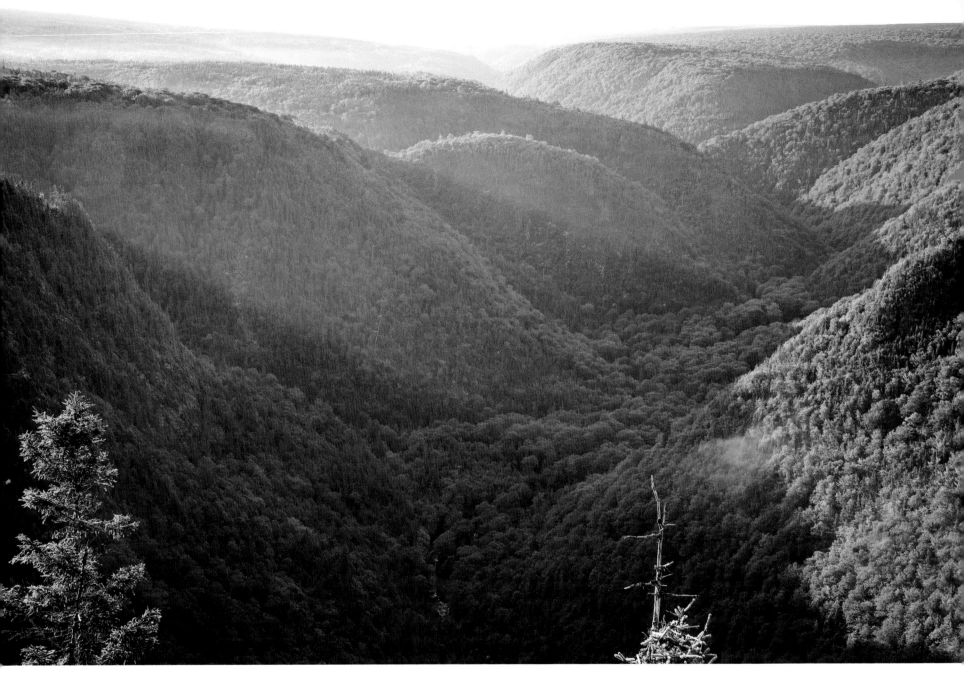

*First Fork Brook Valley*, Margaree River — *(WA) North 46 28.305 West 60 53.263*

*Wild Nova Scotia*

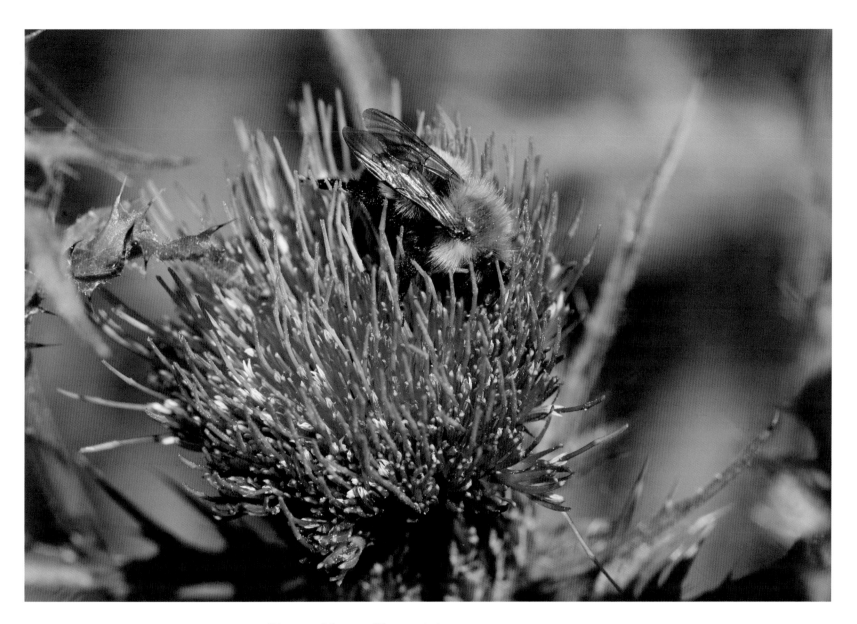

*WILD BEE*, Margaree River — *(WA) NORTH 46 29.122 WEST 60 52.723*

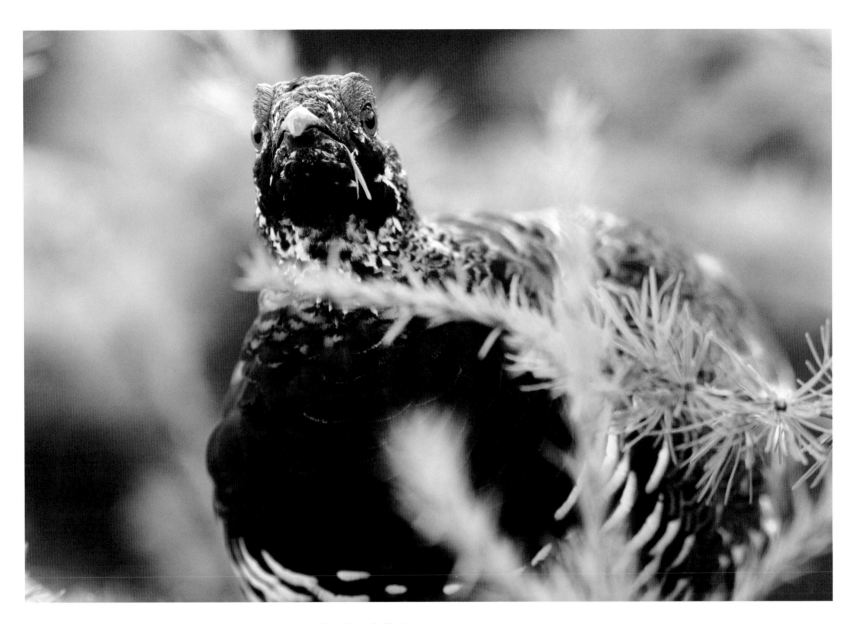

*Spruce grouse*, Jim Campbells Barren — *(WA) North 46 34.228 West 60 53.578*

*Wild Nova Scotia*

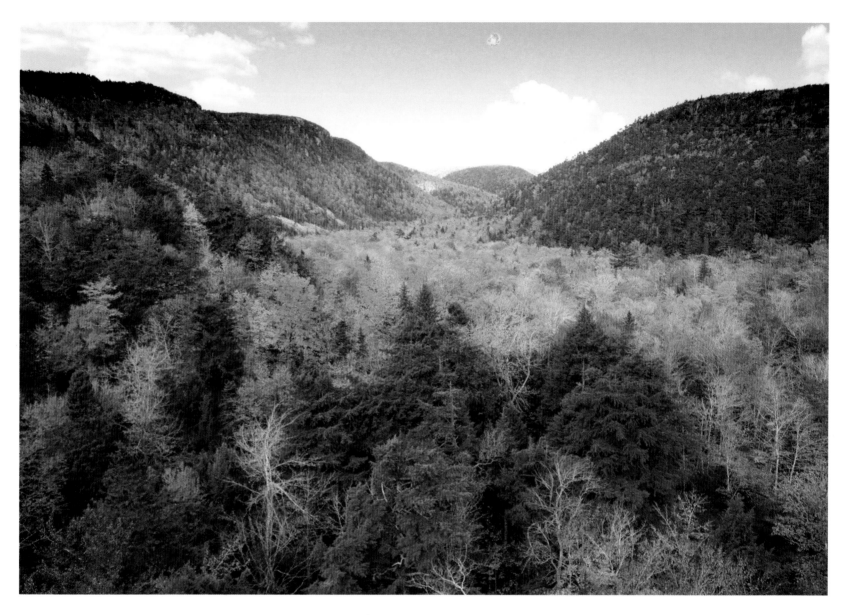

*French River*, French River — *(WA) North 46 27.148 West 60 29.756*

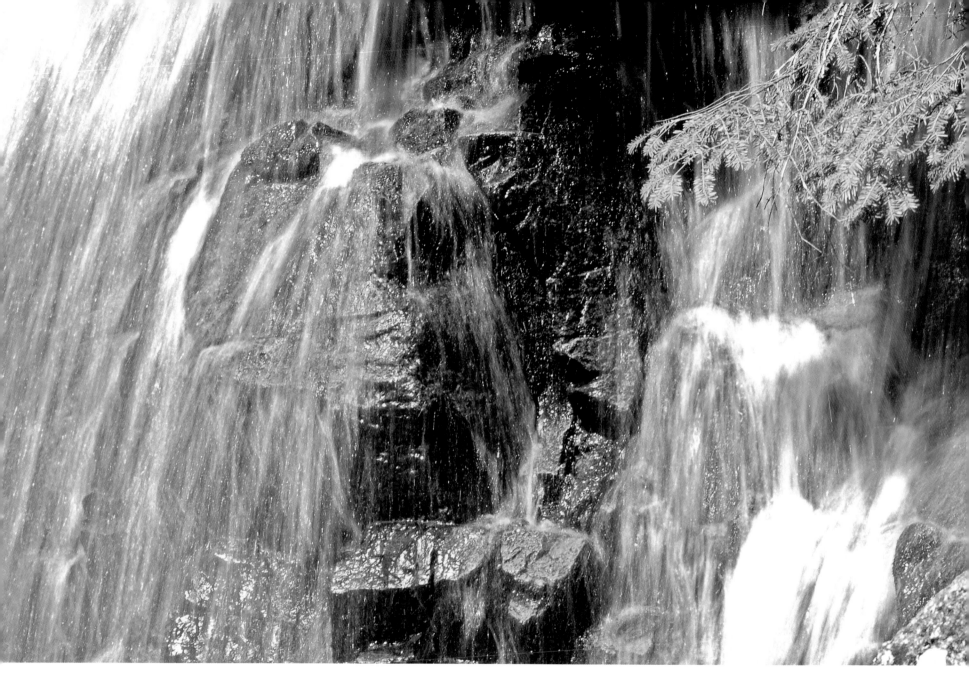

New Harris Settlement, Kellys Mountain — *North 46 14.775 West 60 29.829*

*Wild Nova Scotia*

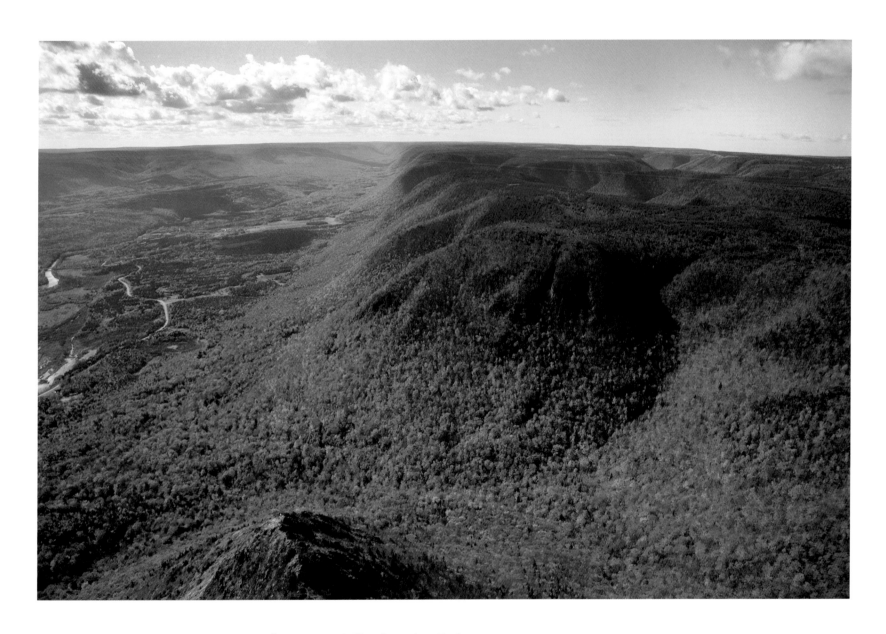

**Above** ‖ *Aspy Fault*, Pollets Cove–Aspy Fault — *(WA) North 46 58.358 West 60 31.727*

**Facing Page** ‖ *Red River*, Pollets Cove–Aspy Fault — *(WA) North 46 49.813 West 60 43.671*

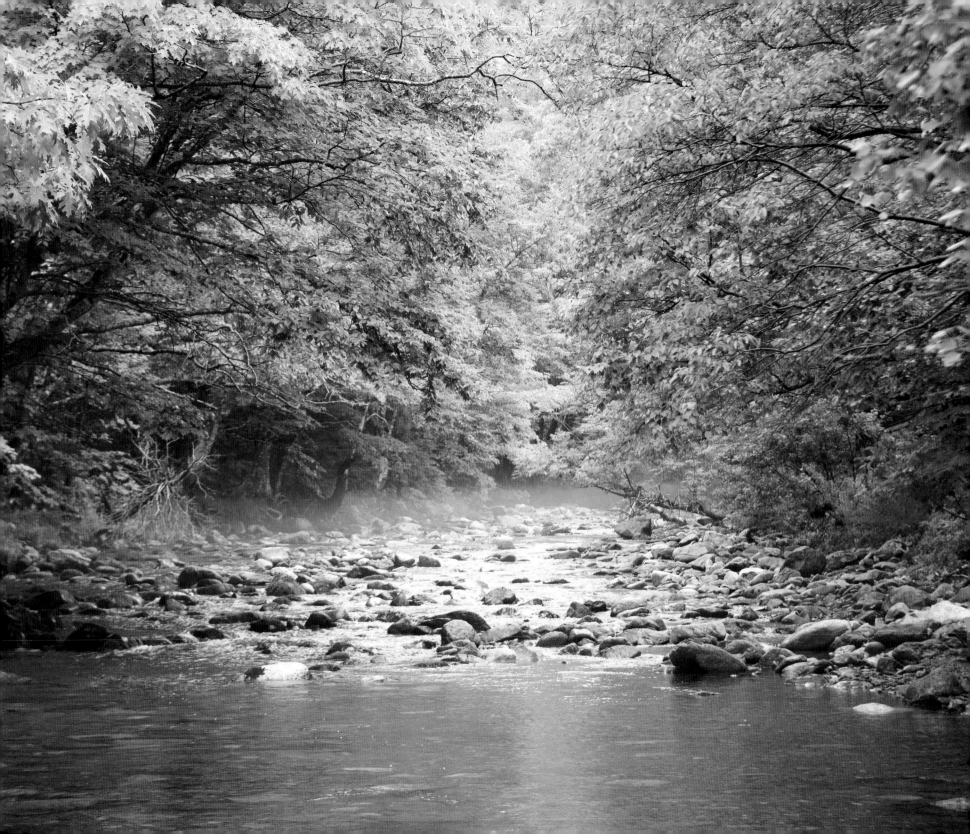

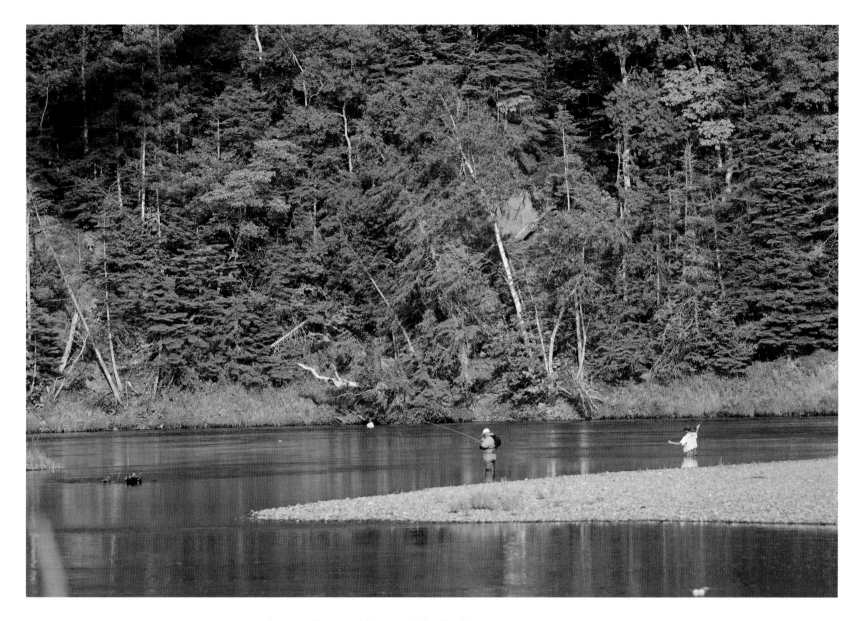

*SALMON FISHING*, Margaree-Lake Ainslie — *(CHR) NORTH 46 19.539 WEST 61 03.247*

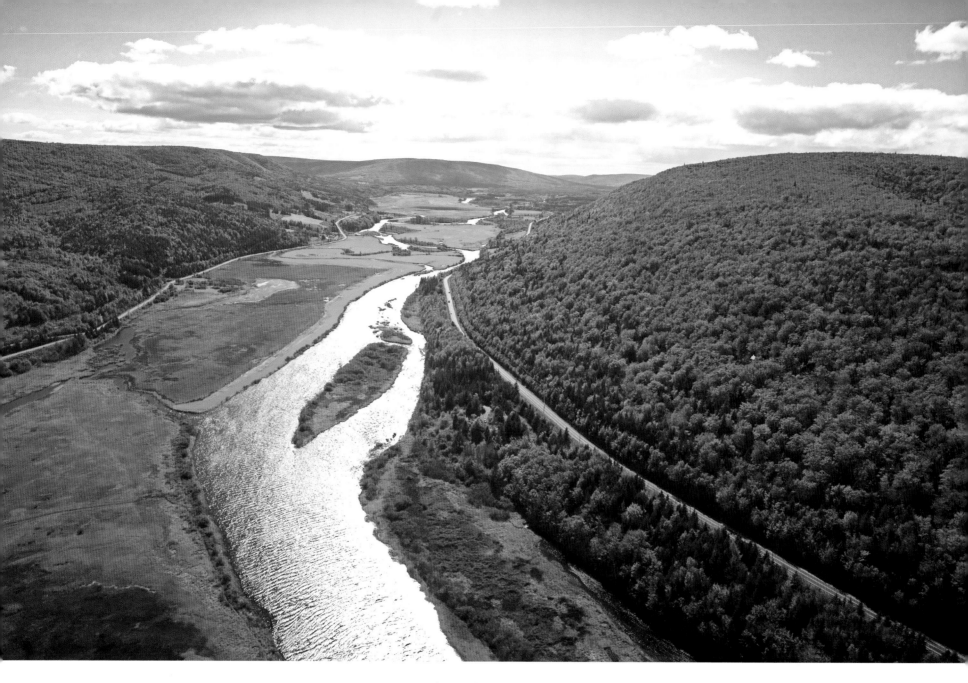

*Margaree River*, Margaree-Lake Ainslie — *(CHR) North 46 23.196 West 61 04.518*

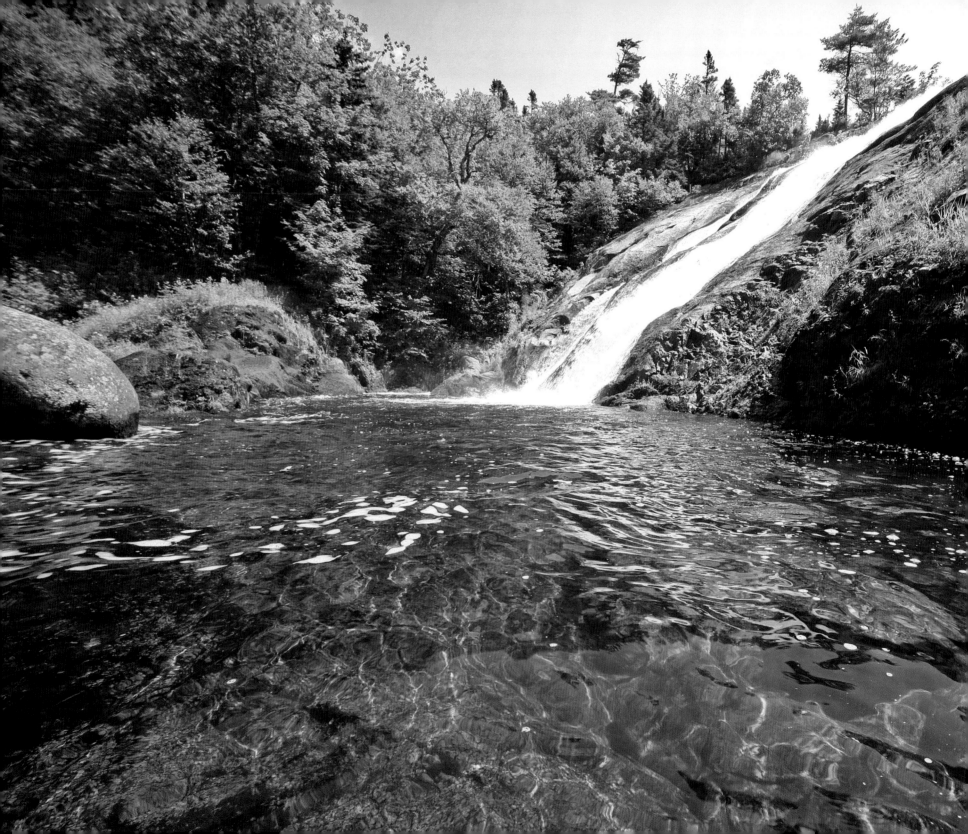

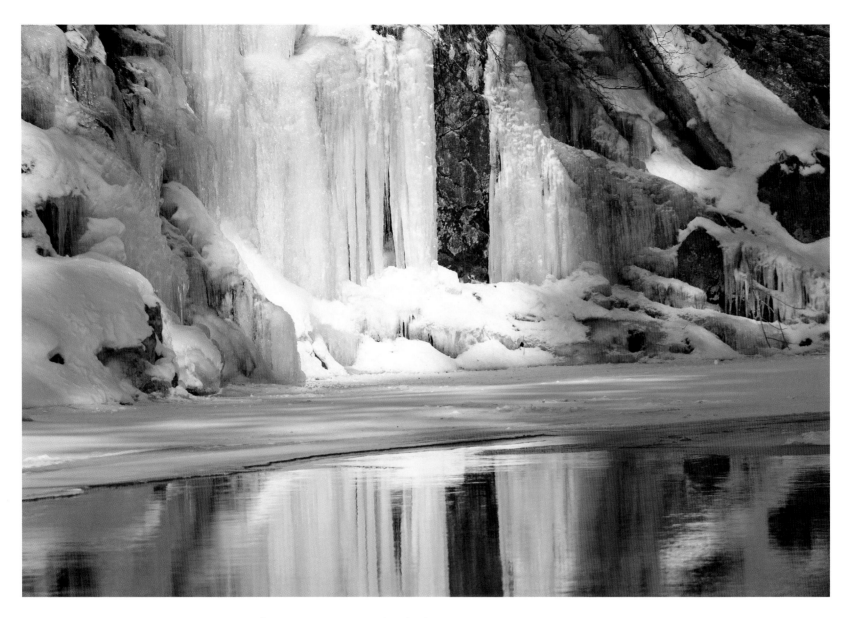

**Above** ‖ *January reflection*, North River — *(WA) North 46 20.516 West 60 41.792*
**Facing Page** ‖ *Second Fork Brook*, Margaree River — *(WA) North 46.29.122 West 60.52.723*

*Wild Nova Scotia*

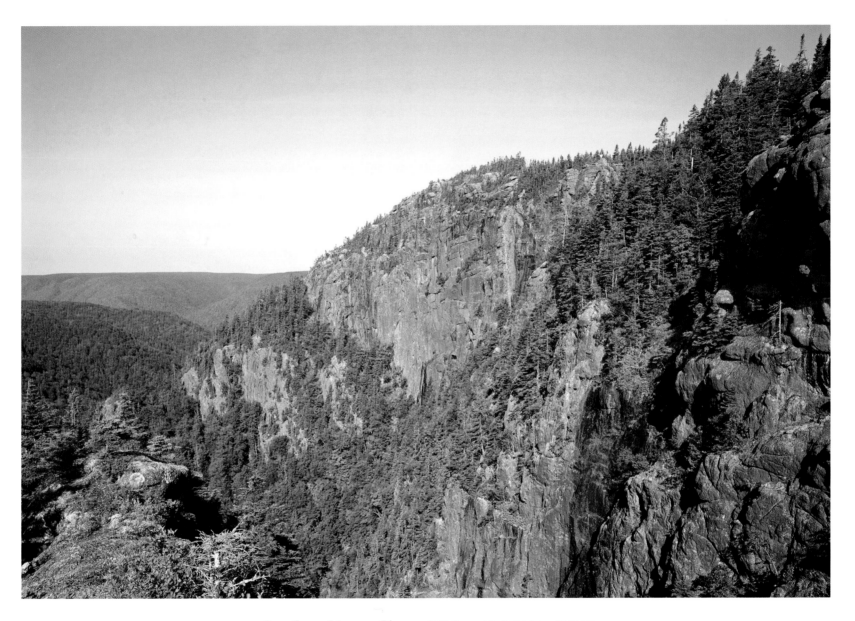

*Cape Clear*, Margaree River — *(WA) North 46 28.334 West 60 53.55*

*Old-growth hemlock*, North River — *(WA) North 46 20.267 West 60 41.207*

*Wild Nova Scotia*

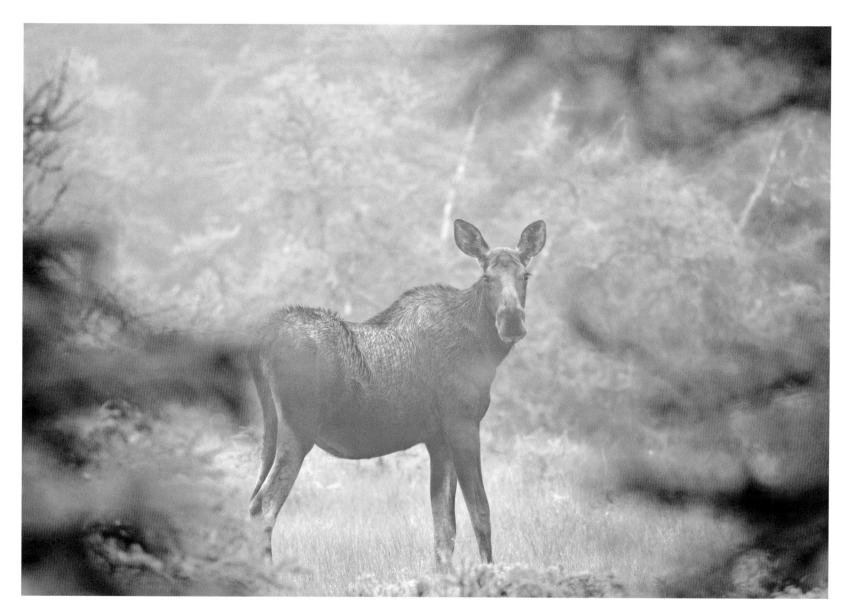

*Moose calf*, Middle River — *(WA) North 46 15.442 West 60 49.445*

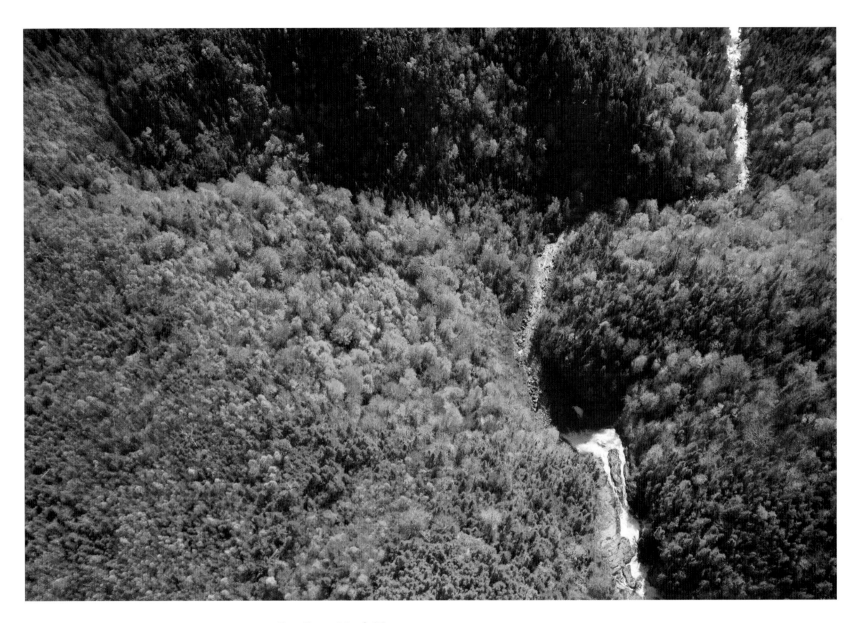

*Fall Falls*, North River — *(WA) North 46 22.216 West 60 41.770*

*Wild Nova Scotia*

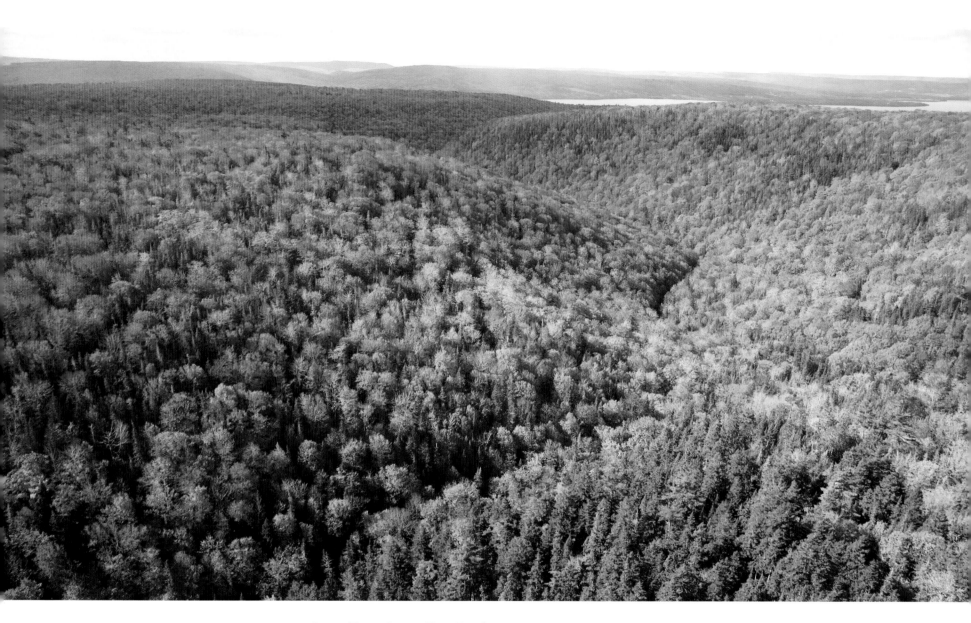

*SOUTH TROUT BROOK,* Trout Brook — *(WA) NORTH 46 06.183 WEST 61 05.004*

# Coastal

The Atlantic coastline along Nova Scotia is salty, damp, rocky, often cool and foggy—yet surprisingly hospitable, with its beaches, cliffs, seascapes, and island havens. Too much exposure can seep into one's blood and mind, helping to define the term "Maritime." The Fundy coastline has similar fog with much higher tides, while the Northumberland Strait sees more sun. The Atlantic coast's finger-like harbours are actually sunken river valleys, with a bountiful sprinkling of island seabird paradises. Such places suit my favourite pastime, messing around in small boats.

White spruce are the most salt-tolerant of Nova Scotia's trees, able to colonize the edges of windswept coastlines where beach grass, beach pea, and roses also stand up to the tides, waves, and ocean spray. Sheltered behind the white spruce, trees like balsam fir, black spruce, birches, and red maples frequently take root in association with other resilient ground cover plants. The persistent dampness promotes luxuriant lichen growth on rocks and trees. Each autumn herds of white-tailed deer move to the shelter of softwood forests along the ice-free Atlantic coast. There they overwinter, venturing onshore to find and eat seaweeds washed in daily on the tides.

Scatarie Island is like a bit of Newfoundland hauled offshore near Louisburg. Biologists introduced ptarmigan and arctic hare from Newfoundland to this island many years ago. The progeny might have survived but for the hunting. As they do on many islands along the Atlantic coast, Leach's storm-petrels dig burrows in the deep soils for nesting. Be careful when landing on this island of cliffs that tower over many sunken ships—I've canoed into Tin Cove on an eight-foot swell and felt fortunate to have made the shore.

Gabarus is quintessential Cape Breton hiking coastline, its isolated headlands interspersed with long, sweeping, memorable beaches.

Washabuck River Nature Reserve has a beautiful floodplain that opens onto Indian Cove, a favourite sheltered anchorage for sailboats off St. Patricks Channel on Great Bras d'Or Lake. The owners of the adjacent land, Jim O'Brien and Henry Fuller, have a conservation easement with the Nova Scotia Nature Trust to protect this property.

The Canso Coastal Barrens are the first mainland Wilderness Area moving from Cape Breton in a southwest direction along the Atlantic shore. This is great country to explore by sea kayak. Not far to the west lies the Bonnet Lake Barrens Wilderness Area, viewable from the Lundy Fire Tower site. Bonnet Lake has beautiful beaches, but access by canoe or foot can be a challenge.

Tangier Grand Lake Wilderness Area borders the Ship Harbour shore, but is best known as a region with a multitude of freshwater lakes. This is a favourite spot for anglers and wilderness lovers—a great place to paddle and portage by canoe or kayak.

The Terence Bay Wilderness Area is a scattering of lakes, woods, and barrens running south from Halifax to the rugged coastline east of Lower Prospect. It offers picturesque coastlines and hiking adventures just outside of the city. And perched at the edge of Halifax Harbour, Duncans Cove, with its coastal barrens and salty ambiance, seems light years away from the bustle of the city. Bowers Meadows Wilderness Area is noted for its eskers—gravels of a riverbed channel that long ago traversed an ice sheet covering this land, leaving an undulating trail after the ice disappeared. This wetland is near the Clyde River, and lies south of Quinns Meadow. Spinney's Heath is an impressive sphagnum bog.

These Coastal sites are a unique and much-cherished environmental blessing encircling Nova Scotia. Live and enjoy it!

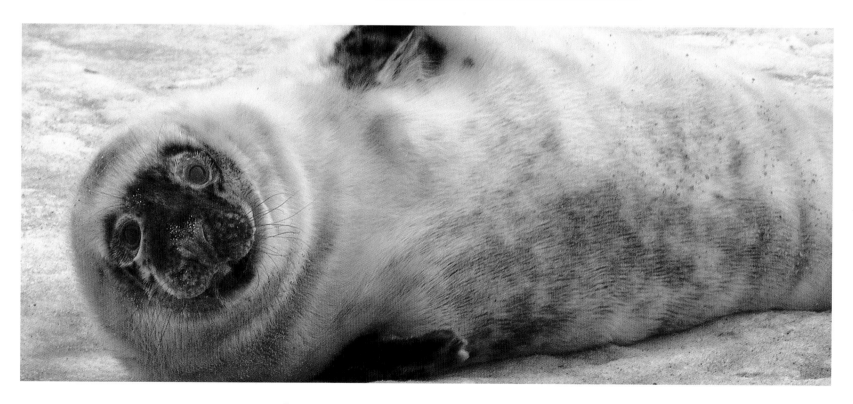

**ABOVE** ‖ *GREY SEAL,* Melmerby Beach — *NORTH 45 40.504 WEST 62 33.713*
**FACING PAGE** ‖ *JOHN JENNEX,* Terence Bay — *(WA) NORTH 44 28.019 WEST 63 41.097*

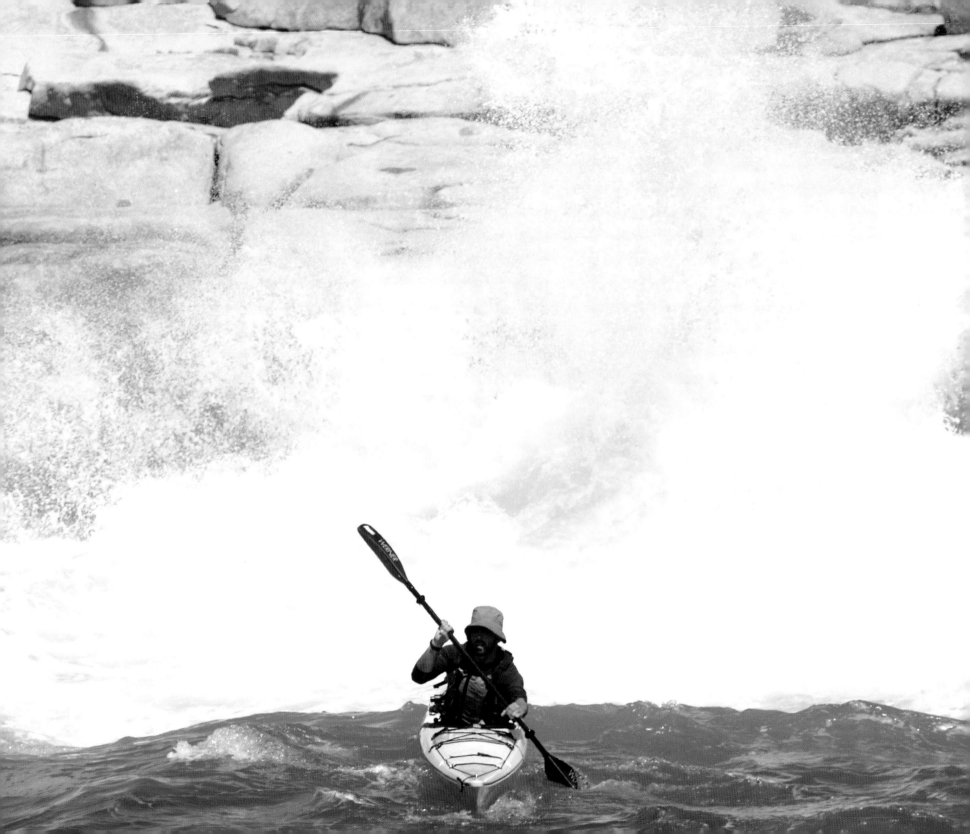

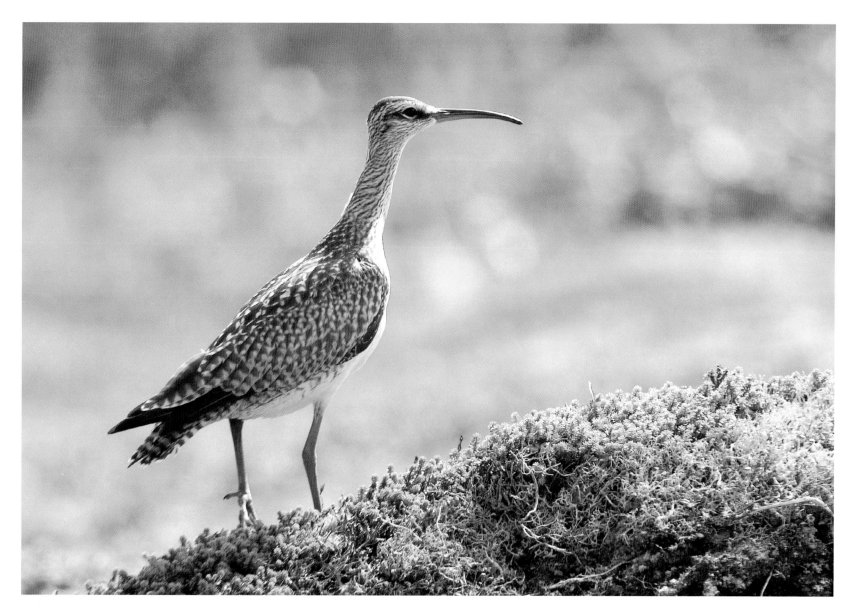

**ABOVE** || *WHIMBREL*, Scatarie Island — *(WA) NORTH 46 02.043 WEST 59 41.008*

**FACING PAGE** || *WINTER COAT*, Sable Island — *(WA) NORTH 43 92.799 WEST 60 01.717*

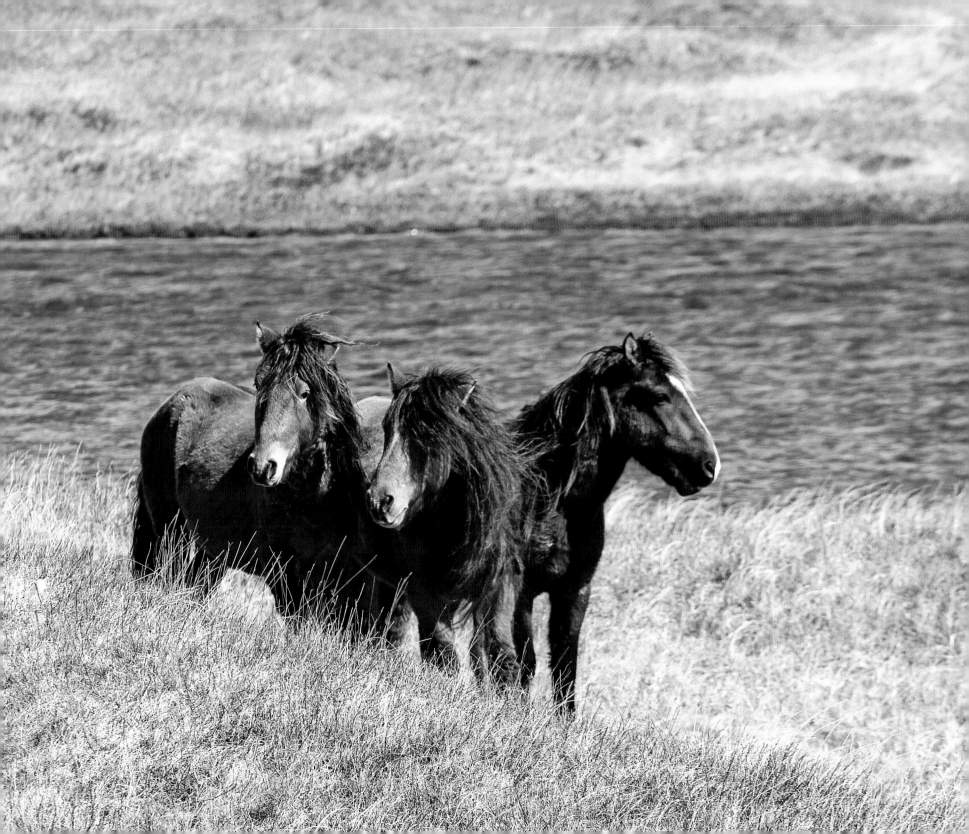

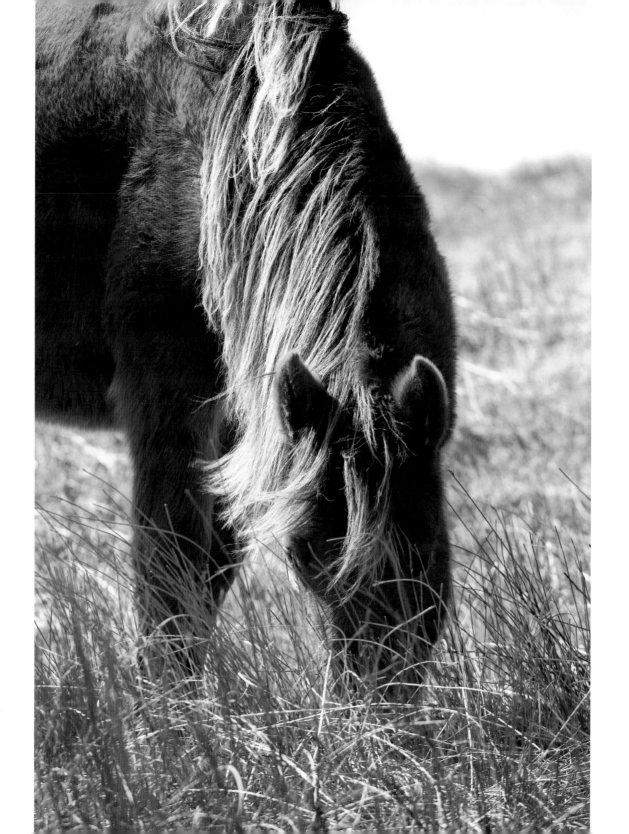

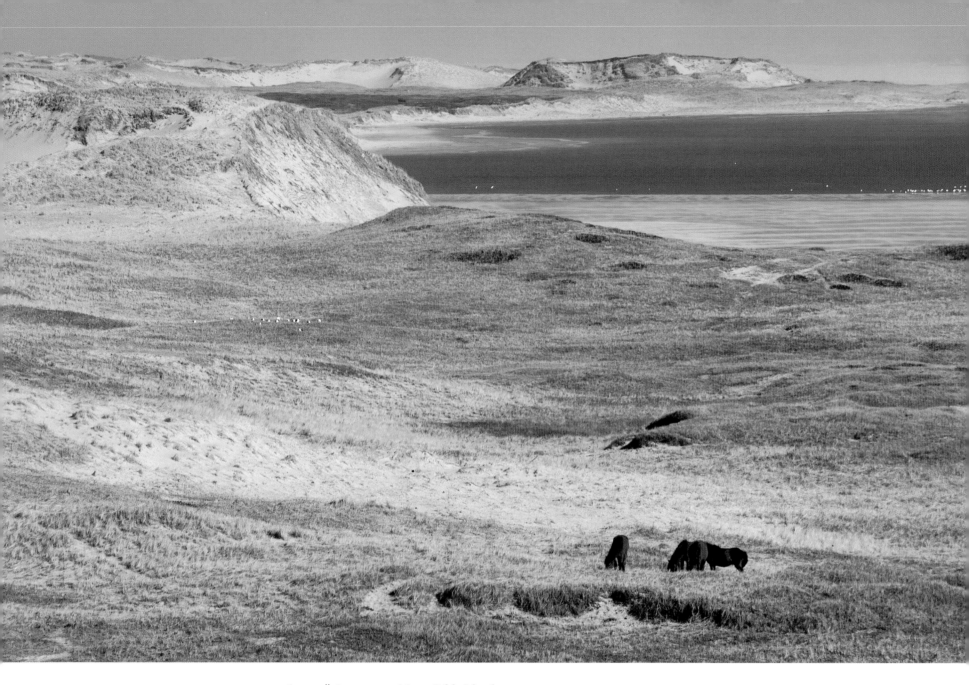

**Above** || *Afternoon Meal*, Sable Island — *North 43 93.438  West 60 00.803*

**Facing Page** || *Sable Island Horse*, Sable Island — *North 43 92.799 West 60 01.717*

*Wild Nova Scotia*

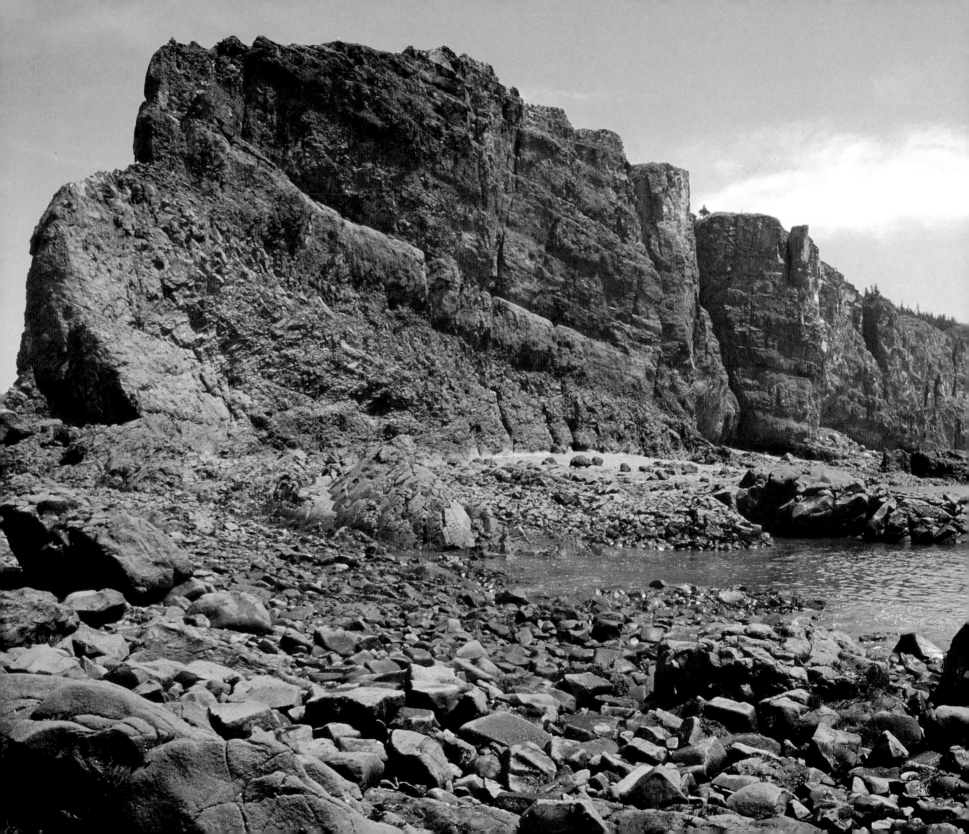

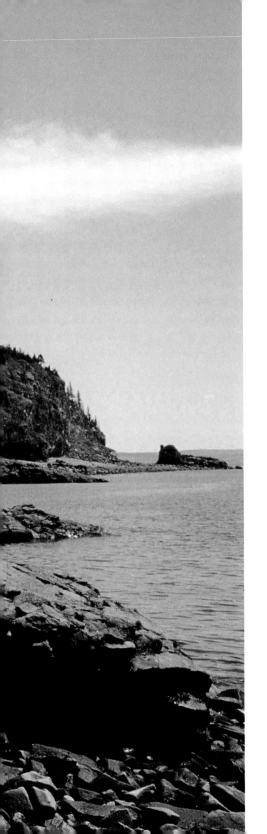

*Cape Split,* Cape Split — *North 45 19.950 West 64 29.66*

*Wild Nova Scotia*

*OLD MAN'S BEARD*, Tangier Grand Lake — *(WA) NORTH 44 54.045 WEST 62 47.189*

*Tangier Grand Lake*, Tangier Grand Lake — *(WA) North 44 53.677 West 62 48.047*

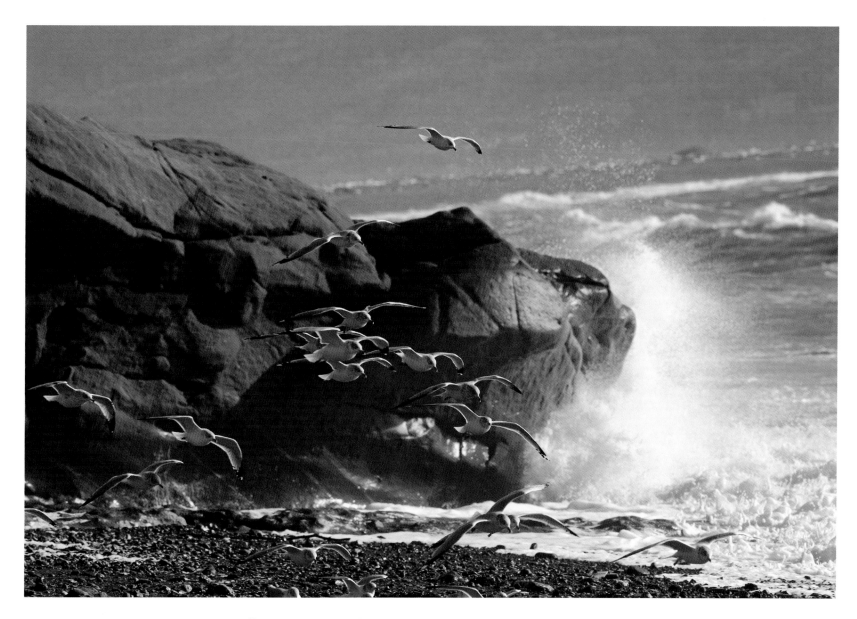

**ABOVE** ‖ *RED ROCKS*, Cape Chignecto Provincial Park — *NORTH 45 21.262 WEST 64 50.610*

**FACING PAGE** ‖ *OCEAN FLOOR*, Cobequid Bay — *NORTH 45 21.319 WEST 63 28.476*

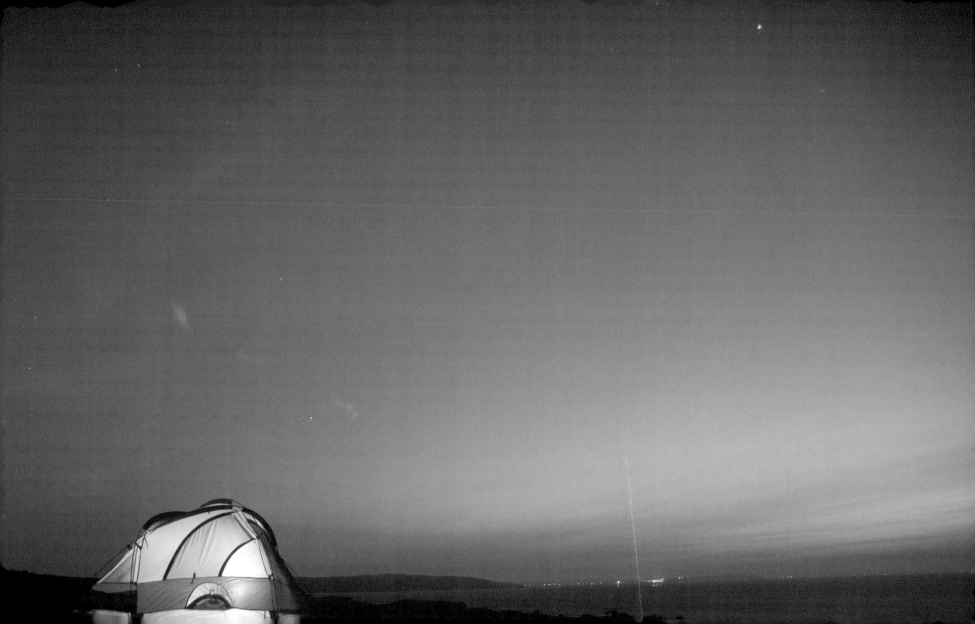

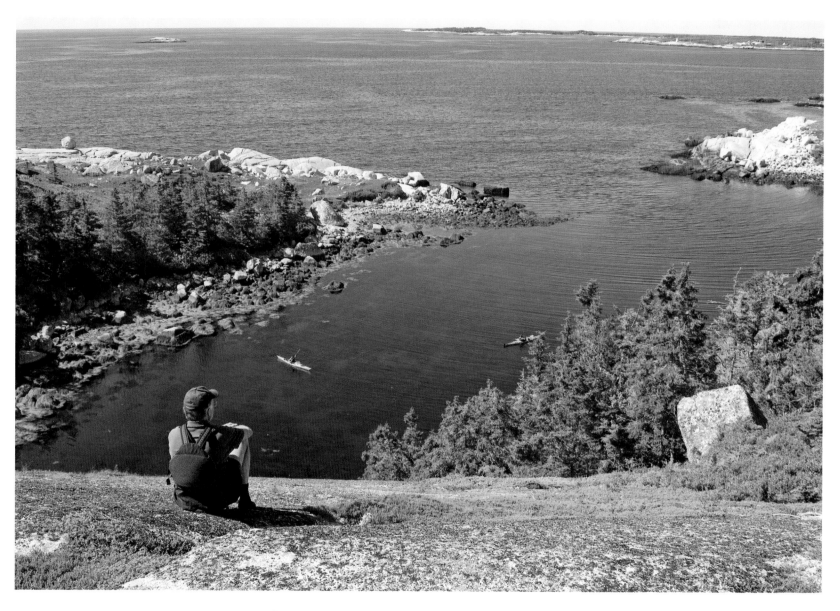

ABOVE || *TERENCE BAY*, Terence Bay — *(WA) NORTH 44 28.255 WEST 63 41.199*

FACING PAGE || *WINGING POINT*, Scatarie Island — *(WA) NORTH 46 01.527 WEST 59 43.843*

*Wild Nova Scotia*

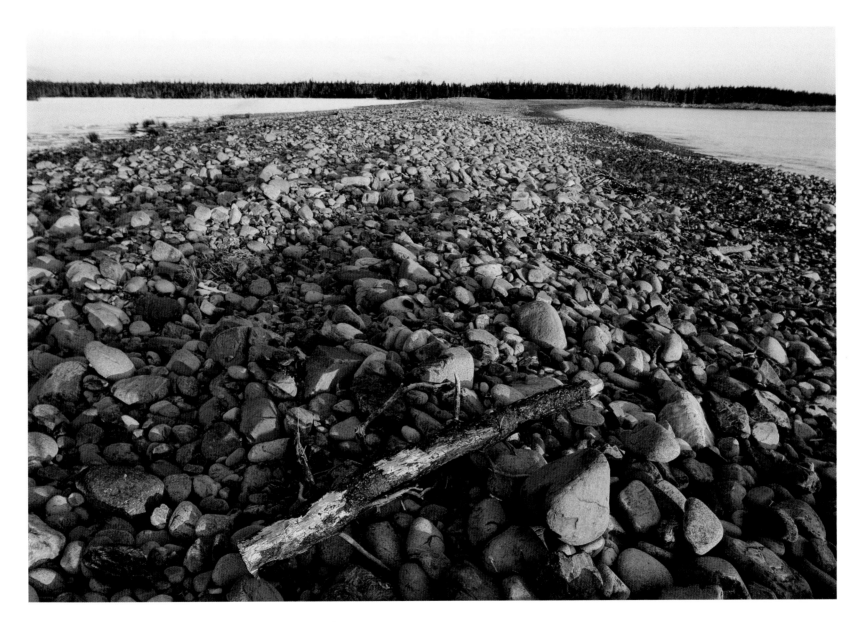

*Harris Beach*, Gabarus — *(WA) North 45 49.380 West 60 07.368*

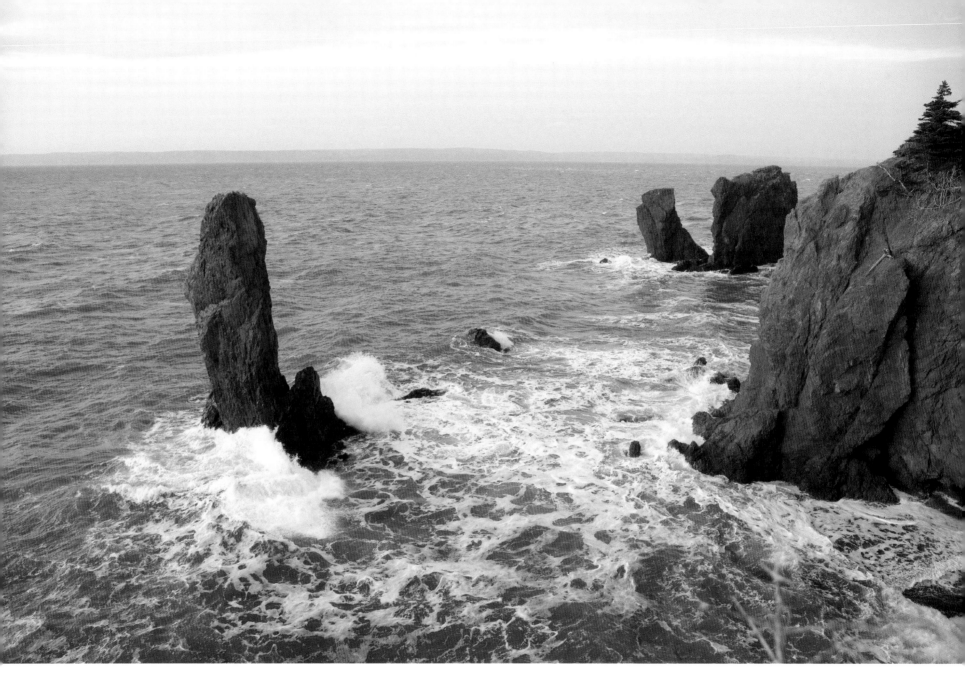

*THREE SISTERS*, Cape Chignecto Provincial Park — *NORTH 45 24.769 WEST 64 55.646*

*Wild Nova Scotia*

*Belfry Beach*, Gabarus — *(WA) North 45 46.315 West 60 11.900*

*Beaver-chewed tree*, Bonnet Lake Barrens — *(WA) North 45 16.451 West 61 26.682*

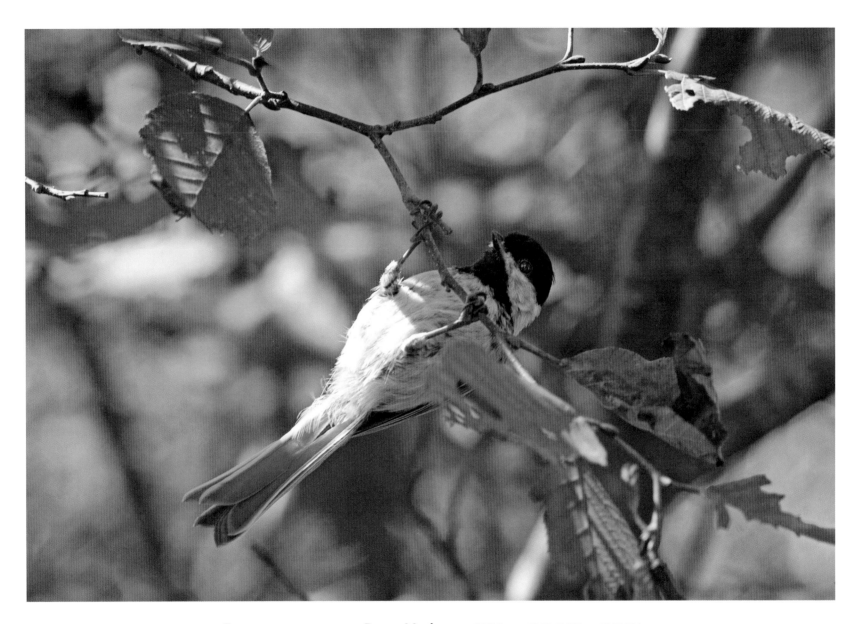

*Black-capped chickadee*, Bowers Meadows — *(WA) North 43 38.629 West 65 23.834*

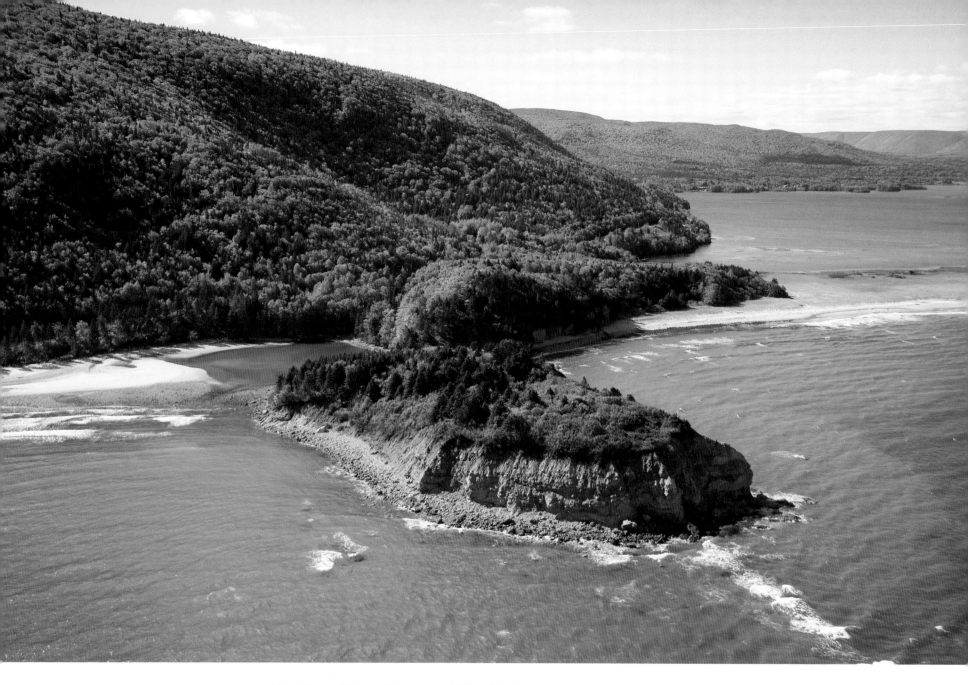

Nova Scotia Nature Trust land, Yellow Head — *North 46 52.642 West 60 24.071*

*Wild Nova Scotia*

*LOUSE HARBOUR*, Canso Coastal Barrens — *(WA) NORTH 45 15.290 WEST 61 02.097*

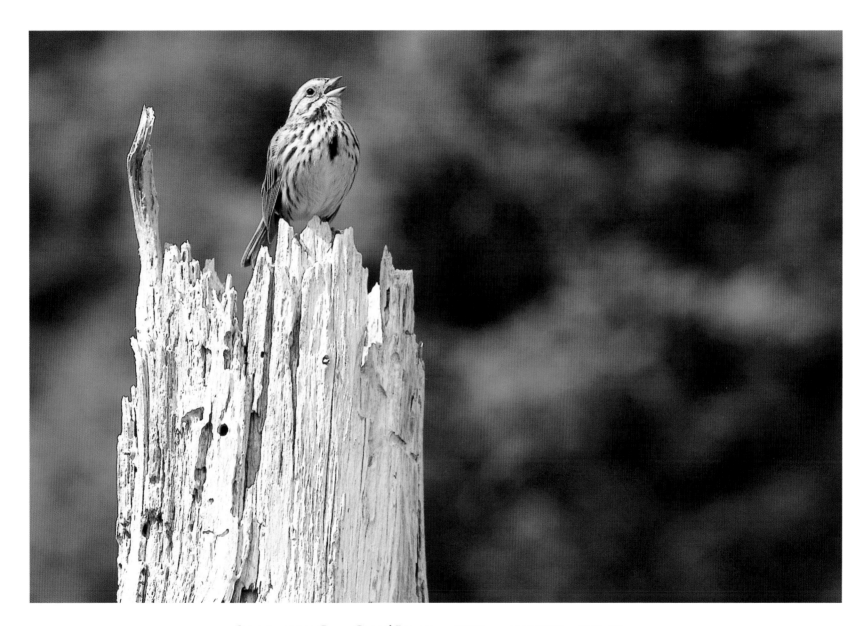

*Song sparrow*, Canso Coastal Barrens — *(WA) North 45 15.850 West 61 01.899*

*Wild Nova Scotia*

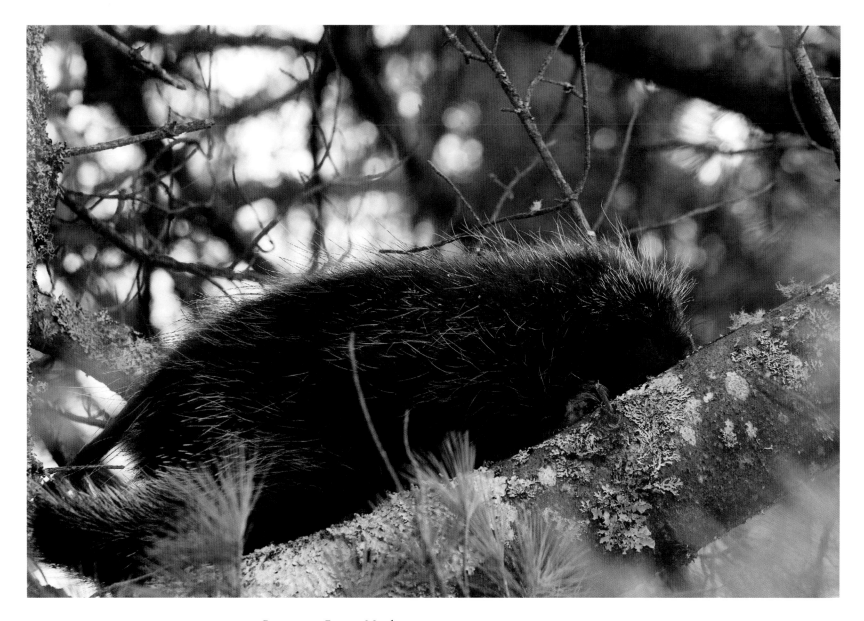

*Porcupine*, Bowers Meadows — *(WA) North 43 39.049 West 65 23.656*

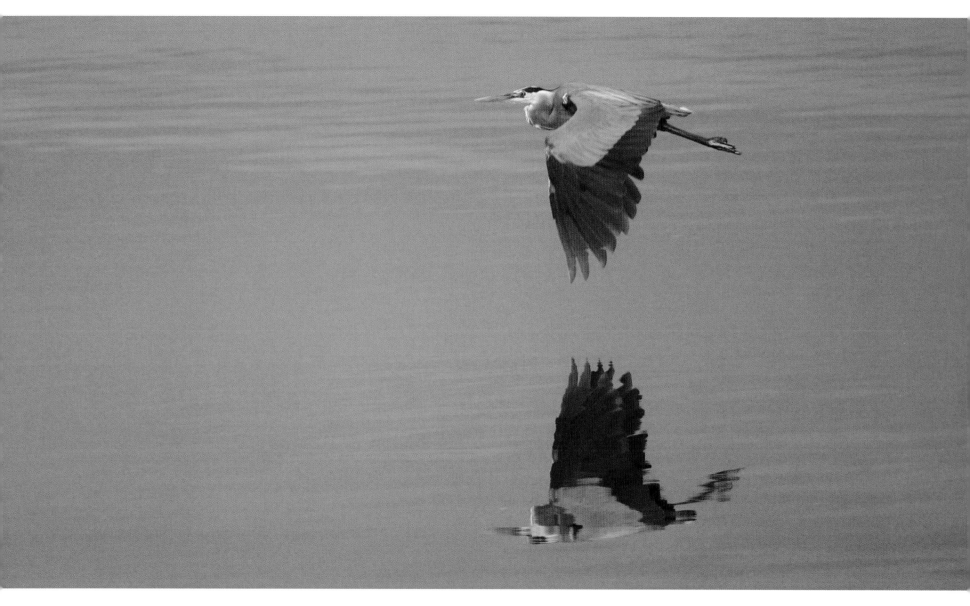

**ABOVE ‖** *BLUE HERON*, Canso Coastal Barrens — *(WA) NORTH 45 15.512 WEST 61 01.946*

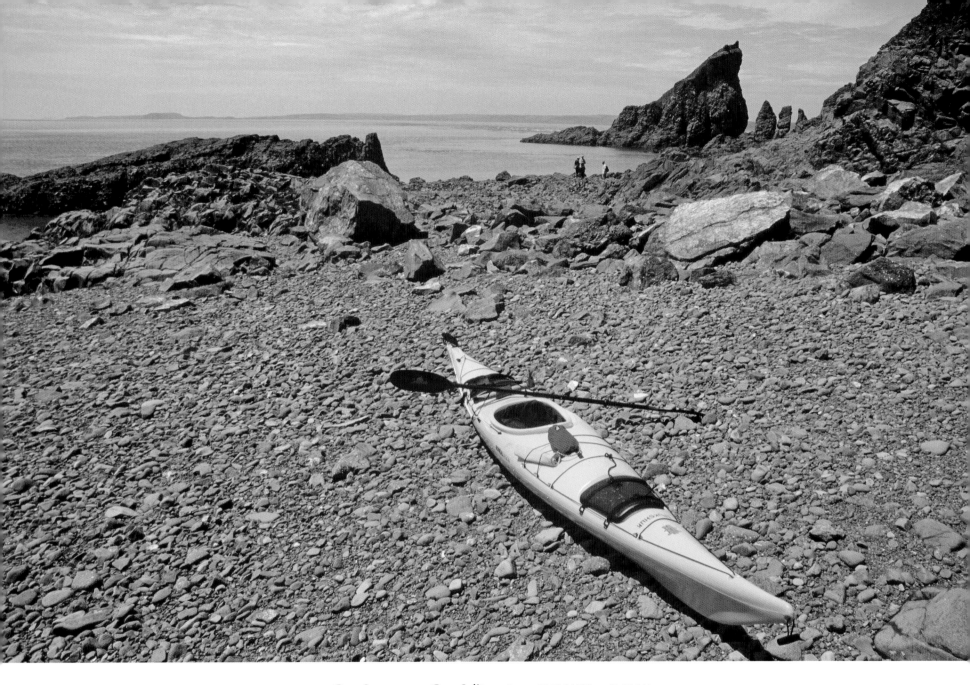

*Cape Split beach*, Cape Split — *North 45 19.809 West 64 29.514*

# Uplands

Upland sites, which tend to be level plateaus at elevations of one hundred to three hundred metres above sea level, undergo more severe winters, higher rates of precipitation, and shorter growing seasons than the lowlands around them. Uplands are never as high as—nor is the climate as harsh as on—the Highlands. Margins of the plateaus often drop off abruptly, creating scenic views. The well-drained, fertile soils support a rich combination of hardwoods and mixed (hardwood/softwood) forests. Trees common on these sites include sugar maple, yellow birch, beech, white, black and red spruce, hemlock, balsam fir, and white pine. The climate is cold in the winter and cool in the summer, with relatively high humidity.

In the Margaree Valley, the river and a geologic fault combine to isolate Sugar Loaf Mountain as an Upland with a climax hardwood ecosystem.

The Economy River, Portapique River, and Gully Lake flow off the Cobequid Hills. Economy Falls can be accessed on a good trail. Portapique River has old-growth forests, rare plants, and interesting geology. Gully Lake is a headwater lake for the Salmon River that empties into the Bay of Fundy. This former hermit hideaway has beautiful hardwood forests.

Softwood forests in the Cobequids tend to grow on poorly drained forest soils. They offer shelter to the threatened mainland moose. Bobcats and eastern coyotes haunt the softwood swamps hunting for snowshoe hare. White-tailed deer leave the open hardwood forests of the hilltops each fall to overwinter on warmer, south-facing slopes. Speckled trout abound in the streams that flow off this Upland. One can watch speckled trout males jousting for prime spawning sites in those streams in late autumn.

Eigg Mountain–James River lies within the Pictou–Antigonish Uplands. The highway around Cape George has been called a mini Cabot Trail. Its mature hardwood, mixed wood, and softwood forests offer isolated habitats for moose and old-growth-dependant species such as fisher, northern goshawks, and barred owls.

The MacFarlane Woods Nature Reserve near Mabou is owned by Jim St. Clair. It holds a rare example of the old-growth hardwoods that used to flourish in this part of Cape Breton. Sugar maple, red maple, and beech with one-metre diameters that stand thirty metres tall are common on this hilltop. Native orchids abound, and northern goshawks are known to use these habitats.

The Bornish Hill Nature Reserve protects a once-common forest of old-growth sugar maples, beech, and yellow birch. There are steep hills, ravines, and several bogs in this site located in the Creignish Hills near Melford, Cape Breton.

Sheltered from the strong winds and extreme snow depths that often batter the Highlands, the Acadian forests of these Upland sites are rich and varied, and contain habitats vital to cavity users like flying squirrels, black bears, bats, and many bird species. These forests feed the aquatic life and filter the water, keeping streams cool and clear, and flowing throughout the summer. There is still much to learn from these Upland forest ecosystems.

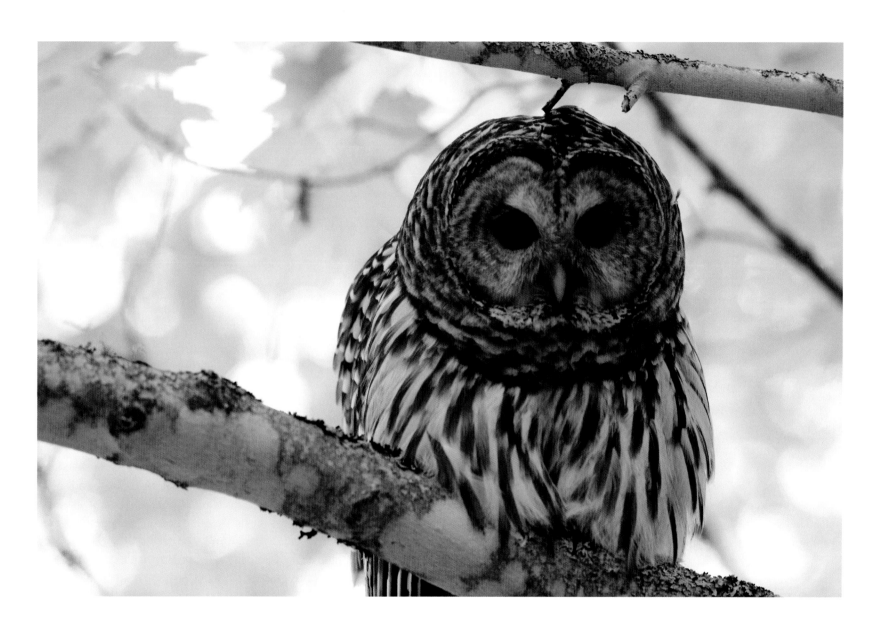

Above ‖ *Barred owl*, Eigg Mountain–James River — *(WA) North 45 41.669 West 62 11.621*
Facing Page ‖ *Hardwood forest*, Cobequid Mountains — *North 45 34.718 West 63 27.907*

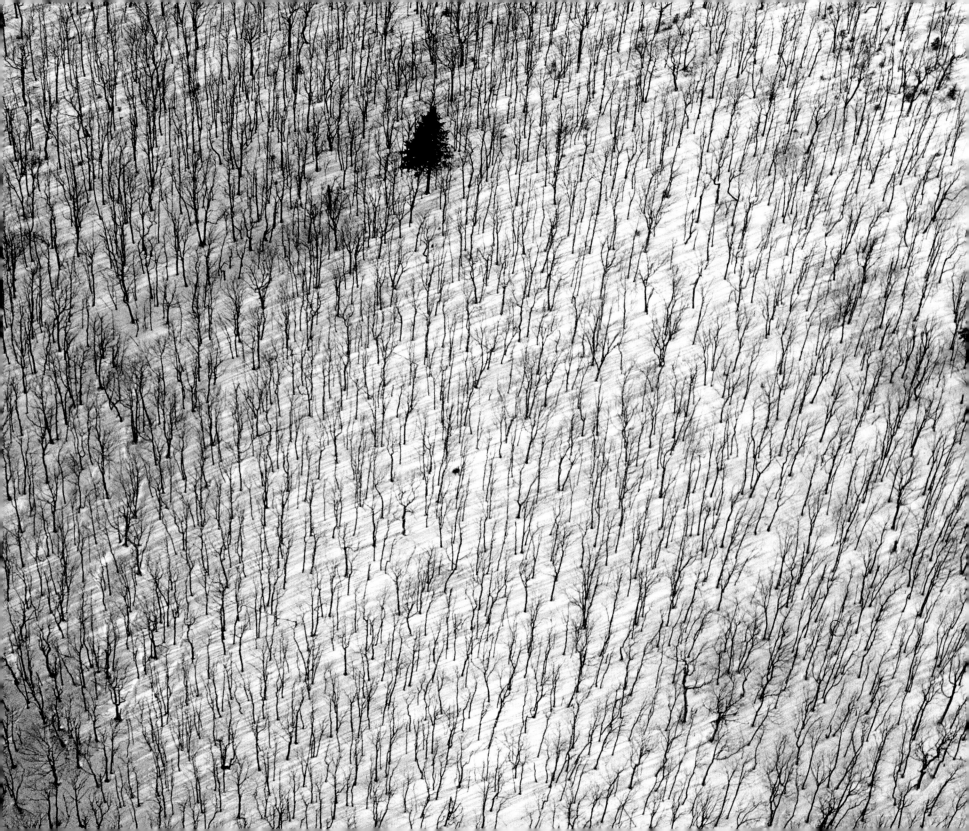

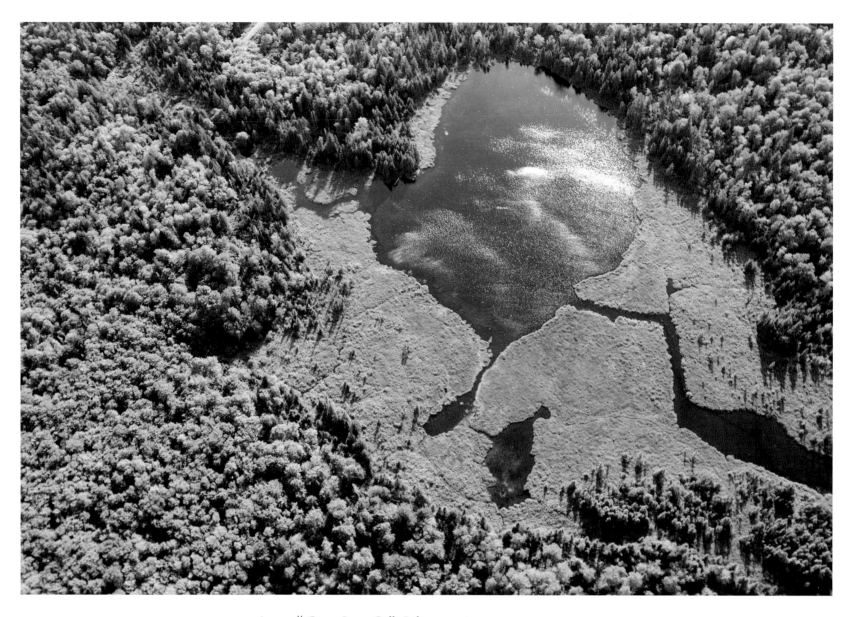

ABOVE || *GULLY LAKE*, Gully Lake — *(WA) NORTH 45 51.400 WEST 63 06.979*

FACING PAGE [CLOCKWISE FROM TOP LEFT] || *BLOODROOT, DUTCHMAN'S BREECHES, TROUT LILY*, Gully Lake — *(WA) NORTH 45 46.967 WEST 63 07.251*

*TRILLIUM*, Economy River — *(WA) NORTH 45 26.668 WEST 63 55.645*

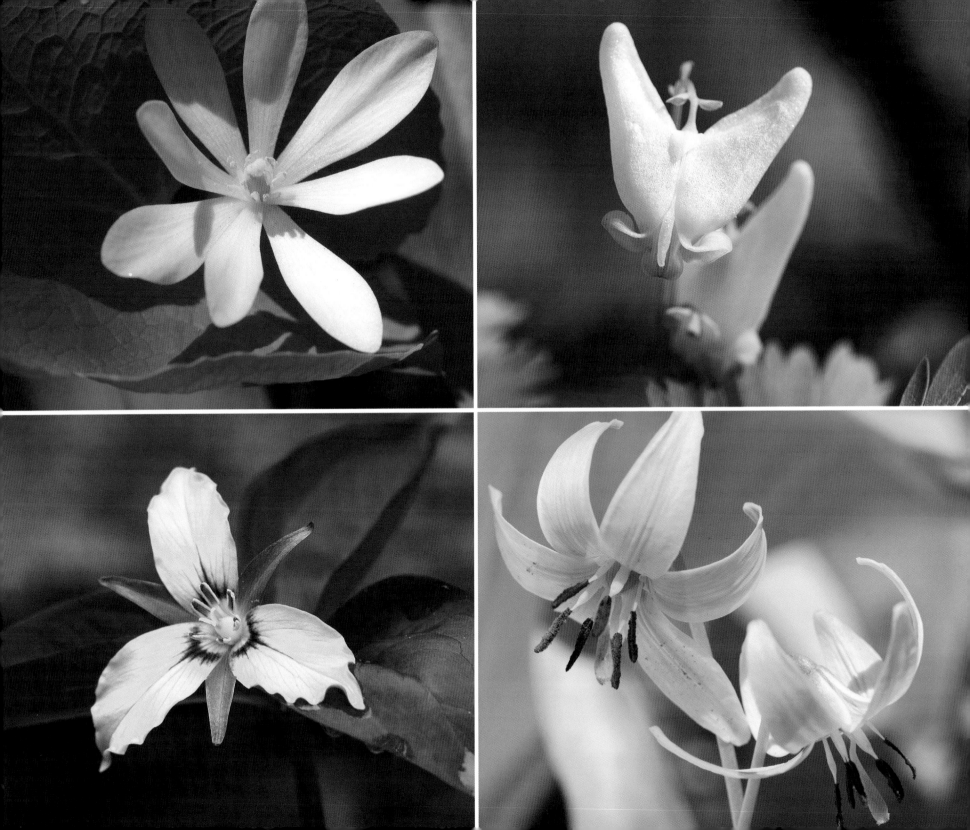

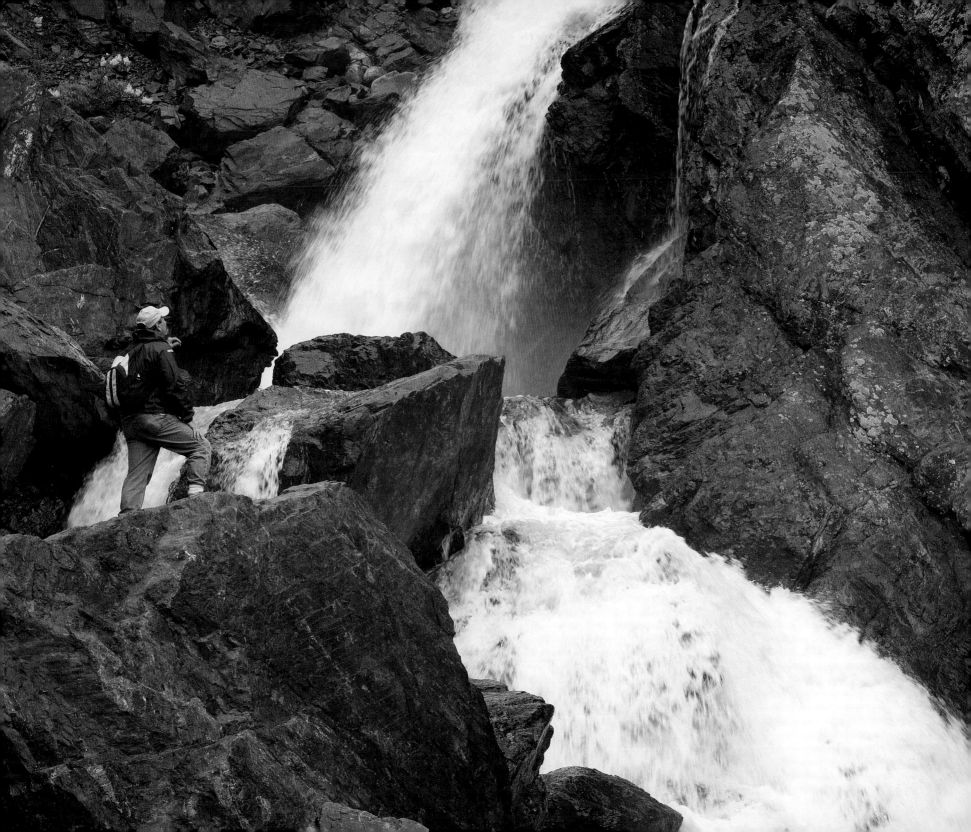

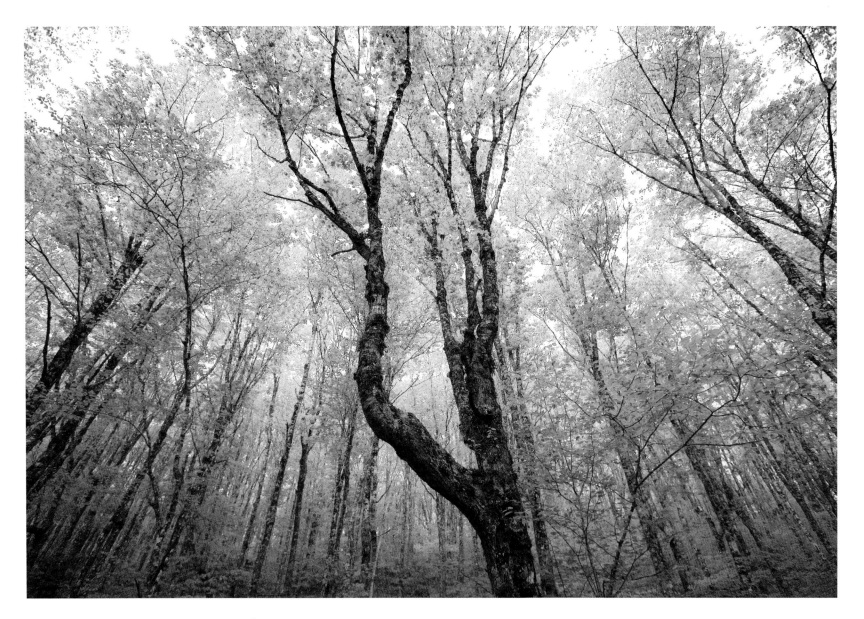

**ABOVE** || *HARDWOOD FOREST*, Portapique River — *(WA) NORTH 45 28.292 WEST 63 43.067*

**FACING PAGE** || *ECONOMY FALLS*, Economy River — *(WA) NORTH 45 26.724 WEST 63 55.170*

*Wild Nova Scotia*

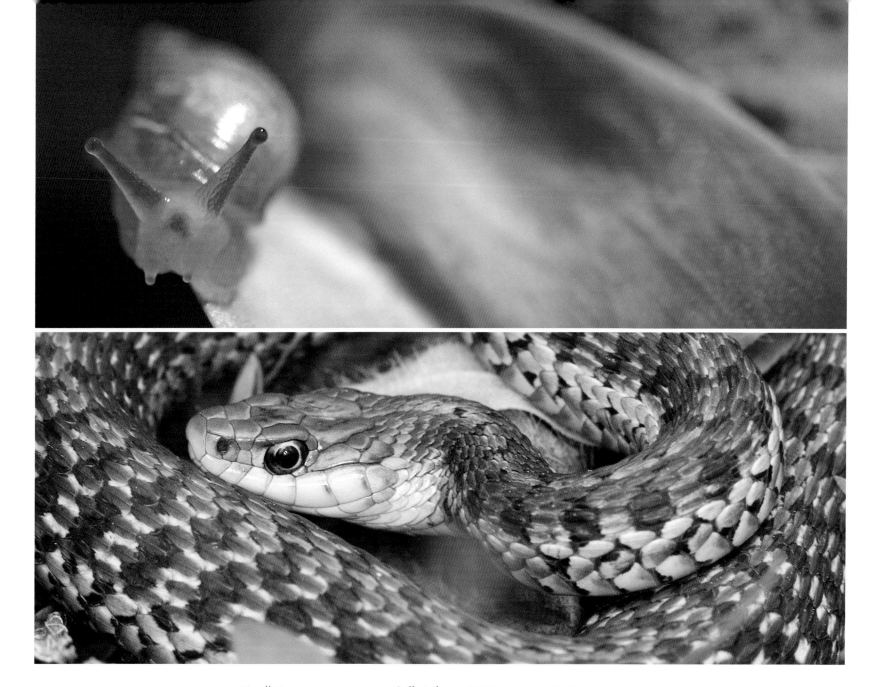

**Top** || *Early morning snail*, Gully Lake — *(WA) North 45 46.967 West 63 07.251*
**Bottom** || *Garter snake*, Portapique River — *(WA) North 45 28.225 West 63 43.835*

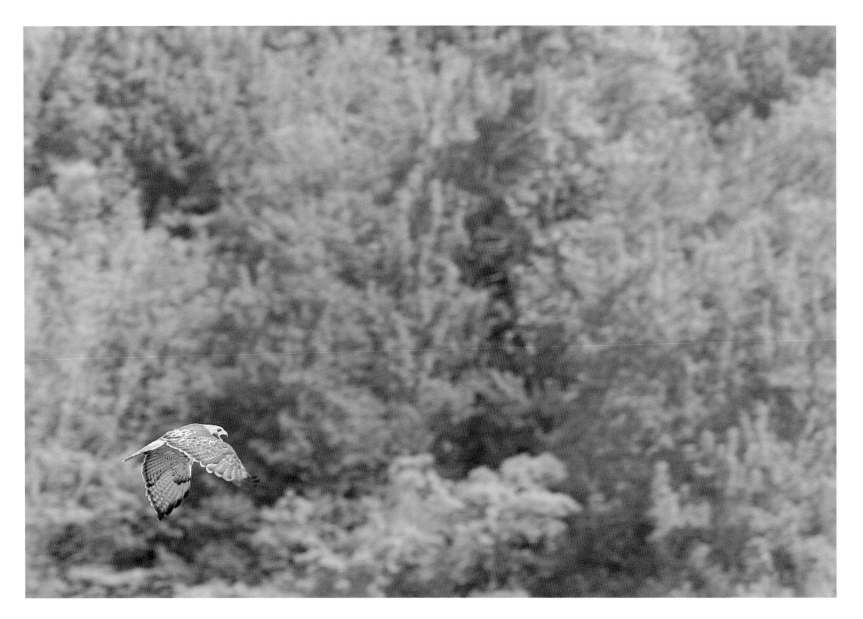

**ABOVE** || *RED-TAILED HAWK,* Bornish Hills Nature Reserve — *NORTH 45 53.521 WEST 61 16.770*
**OVERLEAF** || *PORTAPIQUE RIVER,* Portapique River — *(WA) NORTH 45 28.291 WEST 63 42.865*

*Wild Nova Scotia*

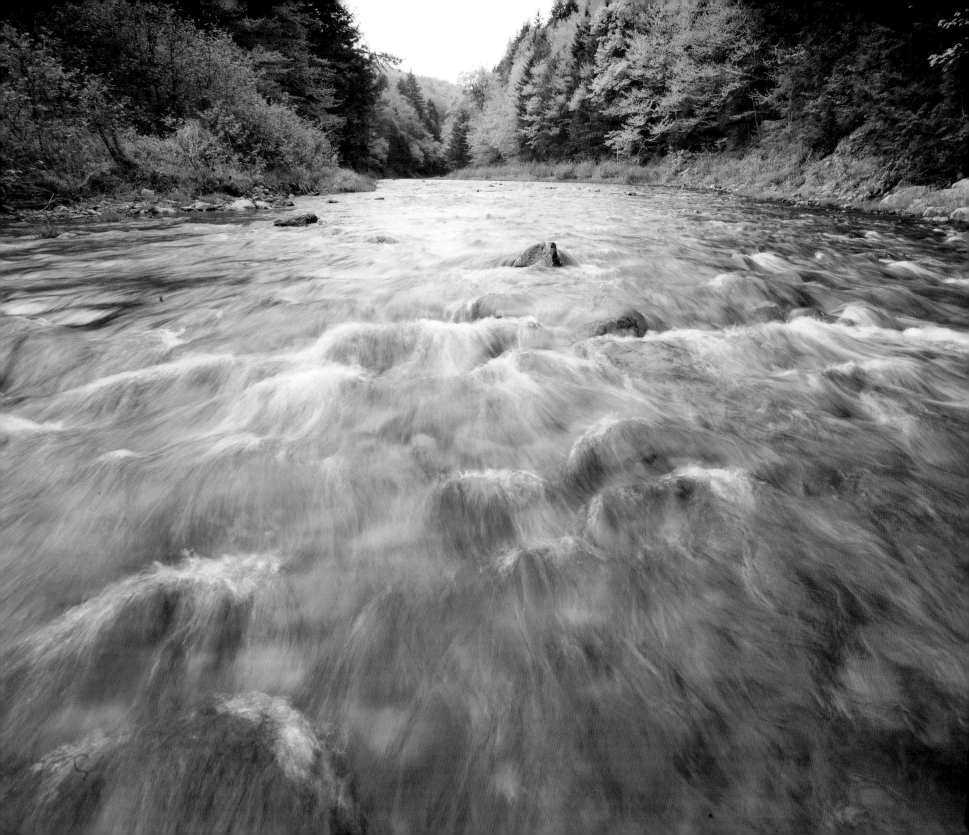

# Interior

NOVA SCOTIA IS RELATIVELY NARROW, WITH AN INVERTED T-BONE SHAPE. INTERIOR LANDSCAPES ARE MULTI-FACETED AND MANY VARIATIONS OF WILDERNESS CAN BE EXPLORED, FROM GEOLOGICALLY DIVERSE LANDFORMS TO RIVERS, LAKES, AND WETLANDS, REVEALING A WIDE ARRAY OF FOREST TYPES AND RARE PLANTS.

For spectacular forests, Indian Man Lake has a rare example of mature mixed-wood forest containing red oaks and white pines, which were once common. Panuke Lake Nature Reserve has one of the best examples of old-growth hemlock and red spruce forest that remain. Many trees there are over three hundred years old. Great Barren Lake and Quinan Lake contain old-growth mixed forest. Dominant species include hemlock more than a metre in diameter, yellow birch, red spruce, sugar maple, and red oak. Sporting Lake Nature Reserve has three small islands covered in primeval hemlock and white pine forests. This land feels like it has escaped the grasp of humans, so tread carefully. Roman Valley contains excellent examples of mature Acadian forest. Abraham Lake's beautiful hiking trail gives one access to the area's mature red spruce forest ecosystem.

For the opportunity to experience both geologic and forest landforms, the Tobeatic region is unparalleled. It has undisturbed examples of many glacial land forms—eskers, kettles, moraines and outwash plains. It has unique barrens, large wetlands, old forest ecosystems, coastal plain plants, and undisturbed wildlife habitats, and it holds the headwaters for nine major river systems, including the Shelburne Canadian Heritage River. This is the largest wilderness area in the Maritimes, with exceptional opportunities for extended travel by canoe.

A canoe will definitely assist your exploration of the province's inland wilderness sites.

Waverley–Salmon River Long Lake offers excellent canoeing and hiking opportunities through landscapes that feature high granite knobs and steep ridges. The woods include old-growth hemlock, spruce, and pines. White Lake is another canoeing favourite, noted for its large, exposed granite ridges. Clattenburgh Brook has folded rock features that create stunning landscapes. Cloud Lake has granite faulted rocks with wetlands and glacial features. It offers portages to other lakes. Cape Breton's Middle River Framboise has drumlins, moulded of loose material mounded into hills by overland movements of a thick ice sheet.

Paddle through River Inhabitants' undeveloped floodplain plants and forests or see Boggy Lake's climax hardwood forests and drumlin hills from the last ice age. Ogden Round Lake, on the eastern mainland Mulgrave Plateau, has notable hardwood Acadian forests as well as fossil rocks. Brown trout prowl its waters. The Lake Rossignol area includes drumlins and quartzite hills with climax hardwood as well as softwood forests and unique pine-ash woodlands. There's also an intriguing wetland called the Big Bog.

The Liscomb River watershed is a traditional canoe route and has three unique Wilderness Areas. The Big Bog is a large, undisturbed wetland that has a raised concentric dome in its middle. The Alder Ground has a number of wetland types concentrated along a section of the river. The Liscomb River Wilderness Area also has more outstanding wetlands, plus the river itself, where sea-run speckled trout seasonally abound. Tidney River has the largest parcel of imperfectly drained softwood forest ecosystem remaining in the province, with large bogs that shelter rare plants. McGill Lake has a complex of wetlands with many diverse plant communities. Ponhook Lake Nature Reserve is a series of island and shoreline properties along the Medway River. Collectively they shelter populations of scarce coastal plain plants that are threatened by shoreline development and human activities. Tusket River Nature Reserve is home to six rare and internationally endangered coastal plain plants that grow along the shore of Wilson's Lake.

Coastal plain sites bordering waterways should only be accessed by guided walks, to safeguard their endangered floral inhabitants. Other Interior sites will often require wilderness gear, skills, and the use of a compass to ensure an enjoyable experience.

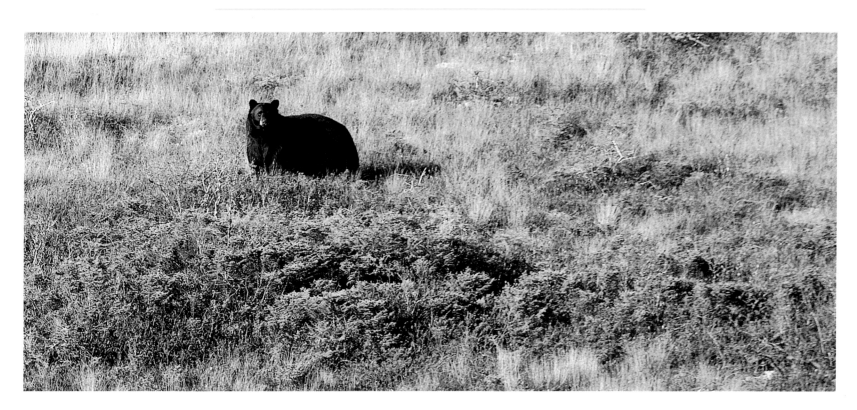

*Black bear,* The Big Bog — (WA) North 45 11.422 West 62 05.816

SPRING RIVER FLOWER, Alder Grounds — *(WA) NORTH 45 08.397 WEST 62 18.057*

*Wild Nova Scotia*

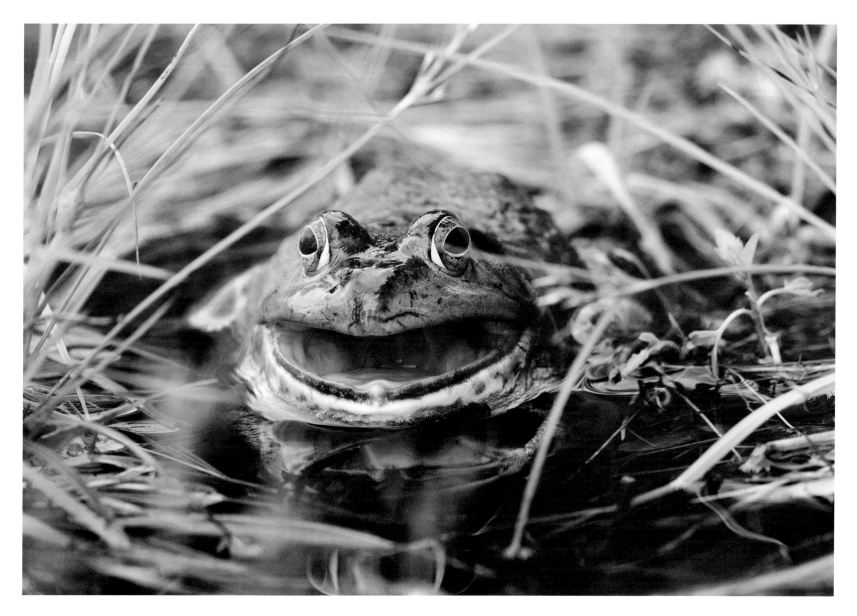

**Above** || *Bullfrog warning*, Cloud Lake – *(WA) North 44 52.020 West 64 53.844*

**Facing Page** || *Spring mayflower*, White Lake — *(WA) North 44 53.391 West 63 14.822*

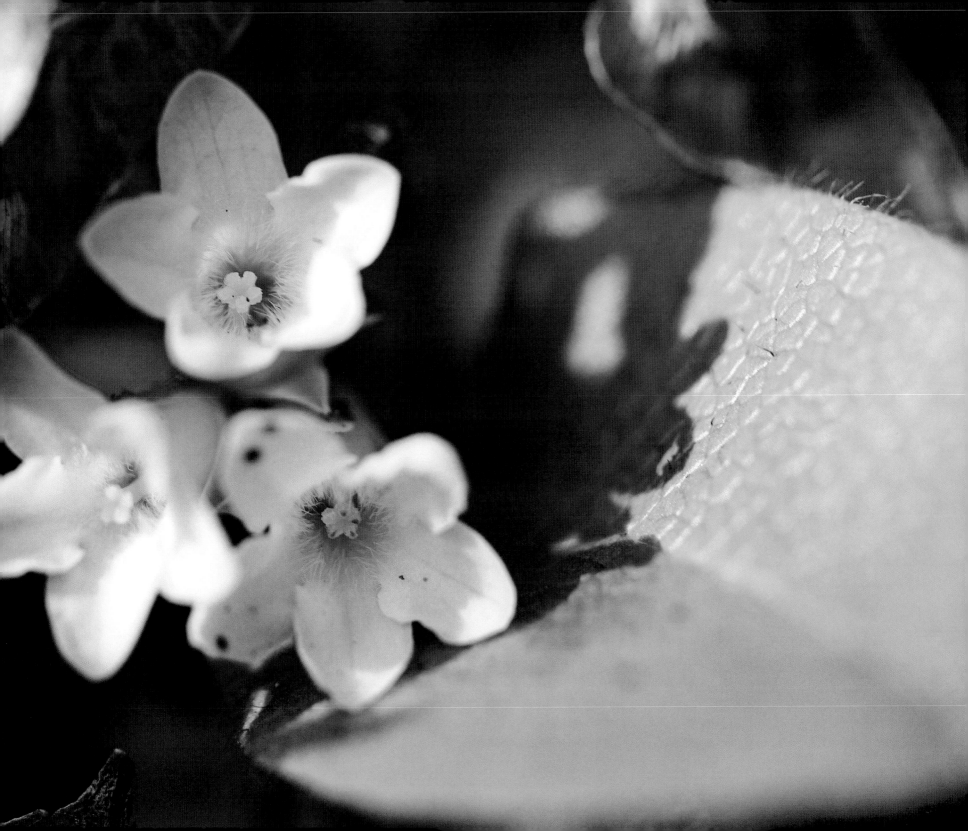

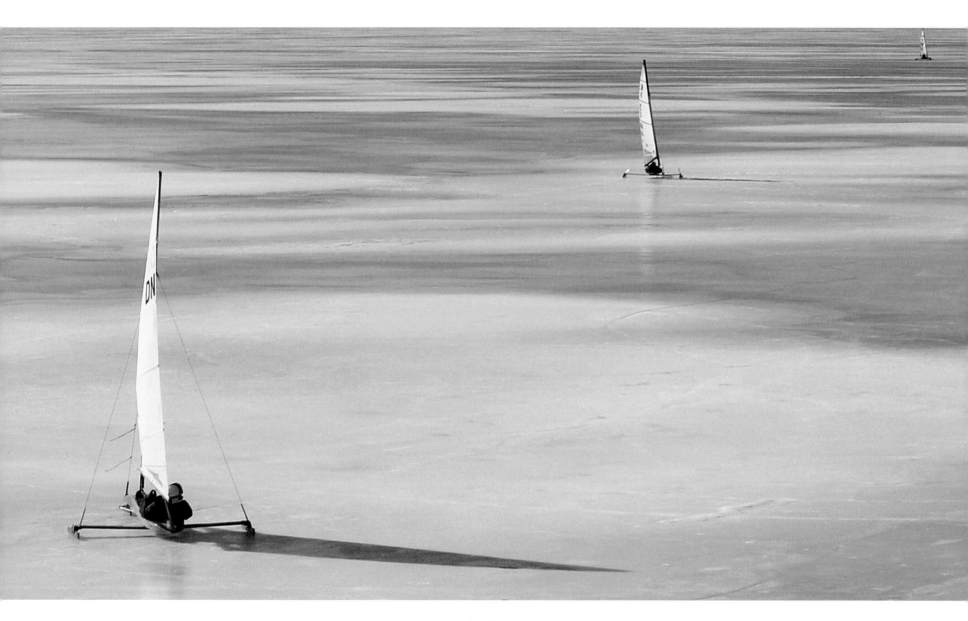

GRAND LAKE ICEBOATS, Grand Lake — NORTH 44 53.374 WEST 63 35.744

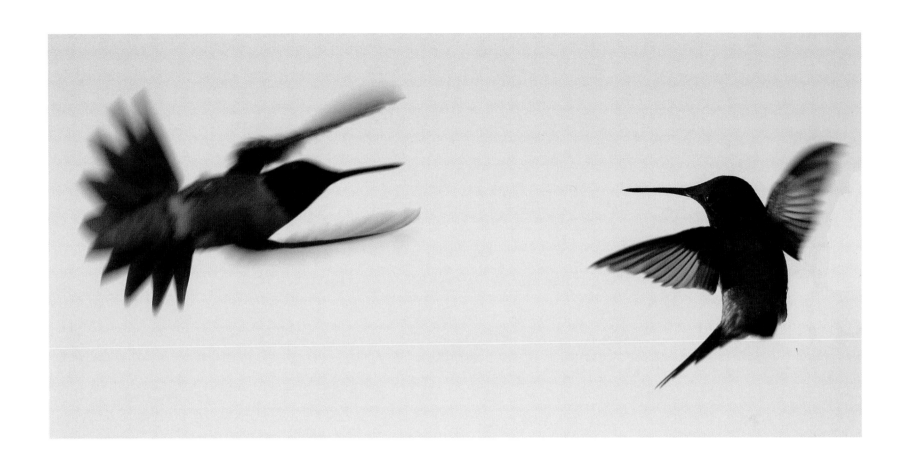

**ABOVE** || *HUMMINGBIRD FEUD*, Wellington — *NORTH 44 51.907 WEST 63 36.779*

*Wild Nova Scotia*

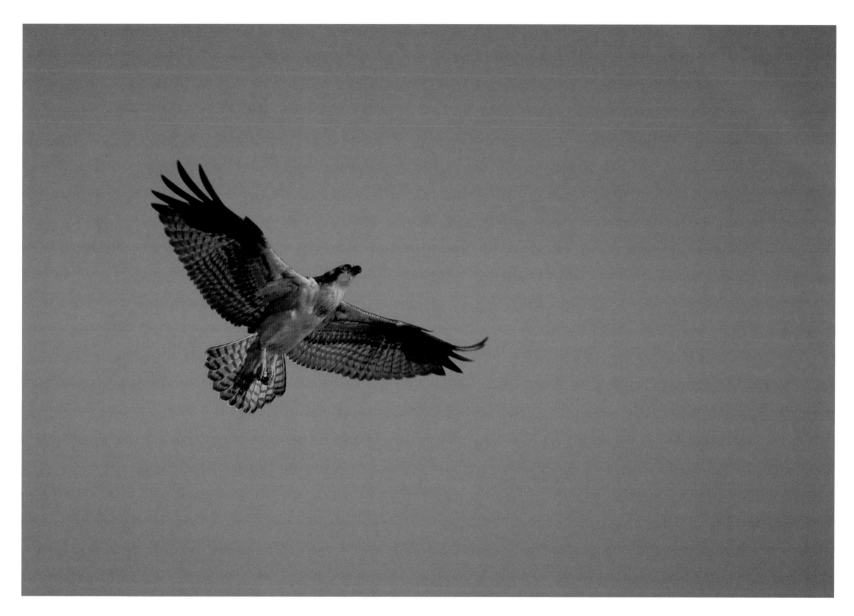

*Osprey parent returns to nest*, Waverley-Salmon River Long Lake — *(WA) North 44 48.925 West 63 33.328*

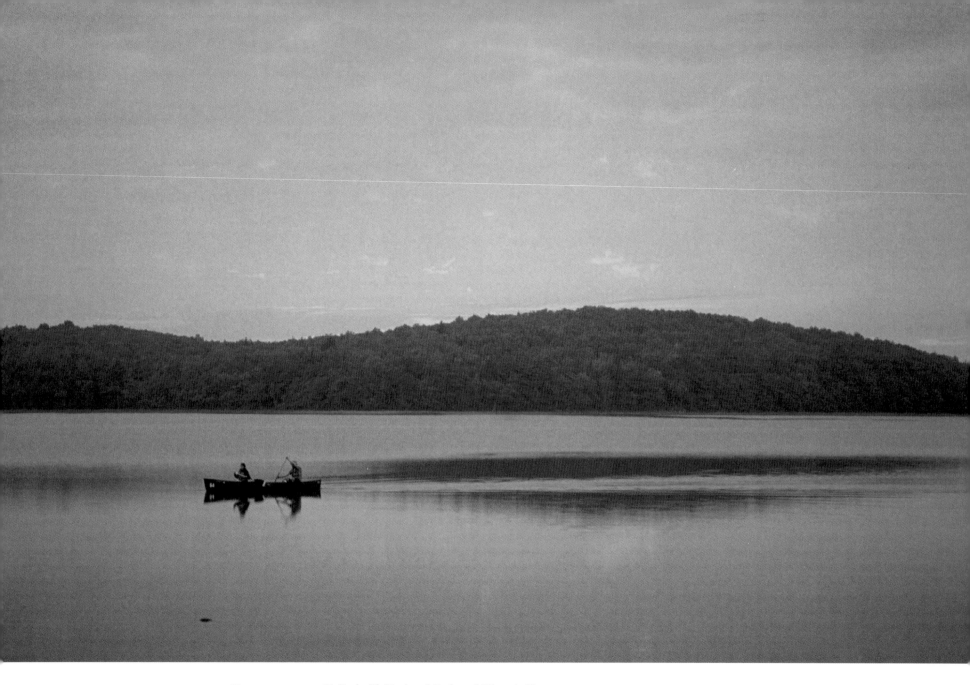

*Evening paddle*, Kejimkujik National Park and Historic Site — *North 44 23.444 West 65 14.774*

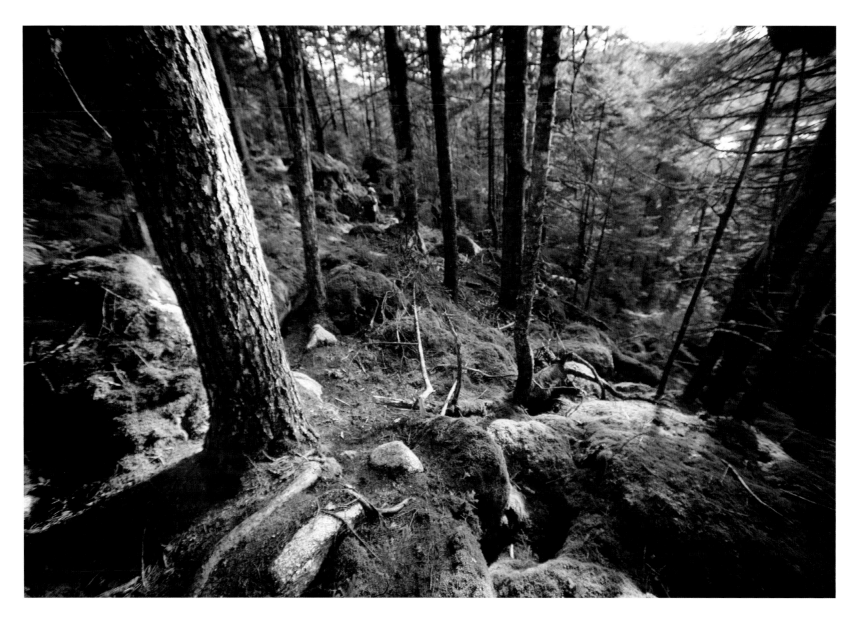

*Forest hikers*, White Lake — *(WA) North 44 52.227 West 63 12.062*

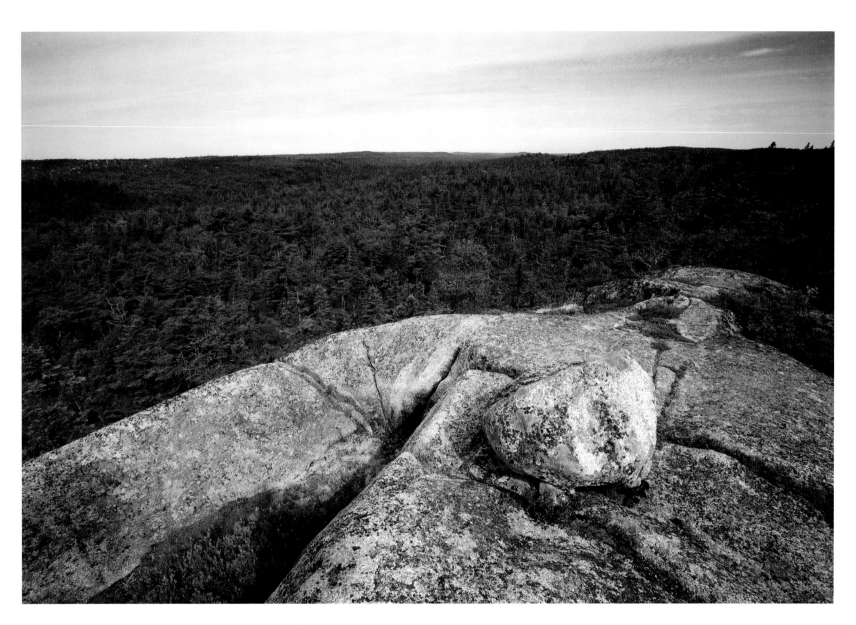

*Lonely look-off*, Waverley-Salmon River Long Lake— *(WA) North 44 46.123 West 63 23.692*

*Wild Nova Scotia*

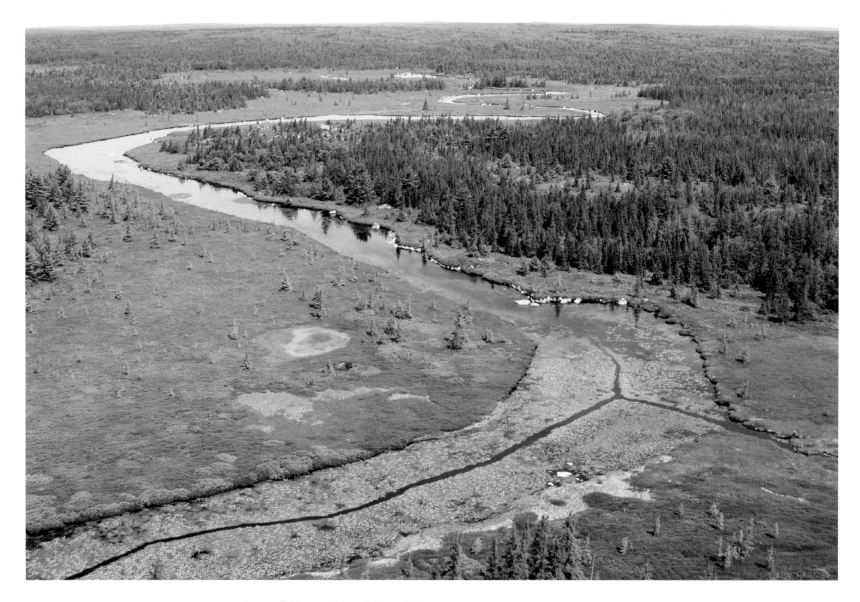

**Above** ‖ *Tidney River*, Tidney River — *(WA) North 43 56.866 West 65 03.637*

**Facing Page** ‖ *Morning mist*, Ogden Round Lake — *(WA) North 45 23.529 West 61 40.117*

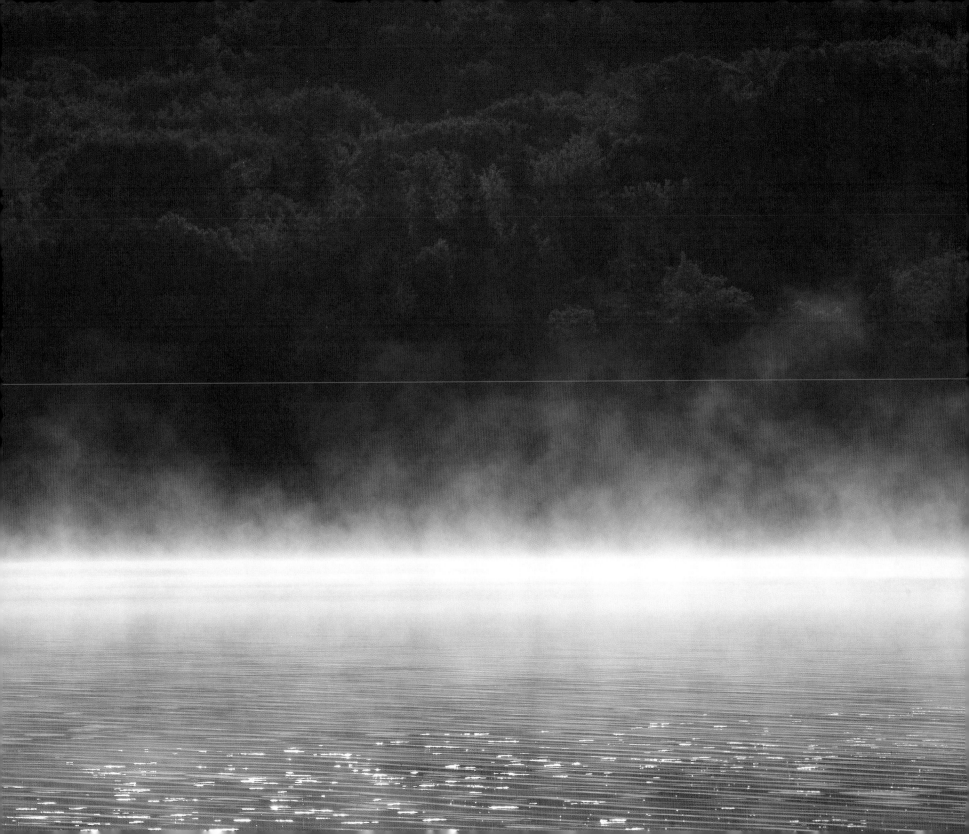

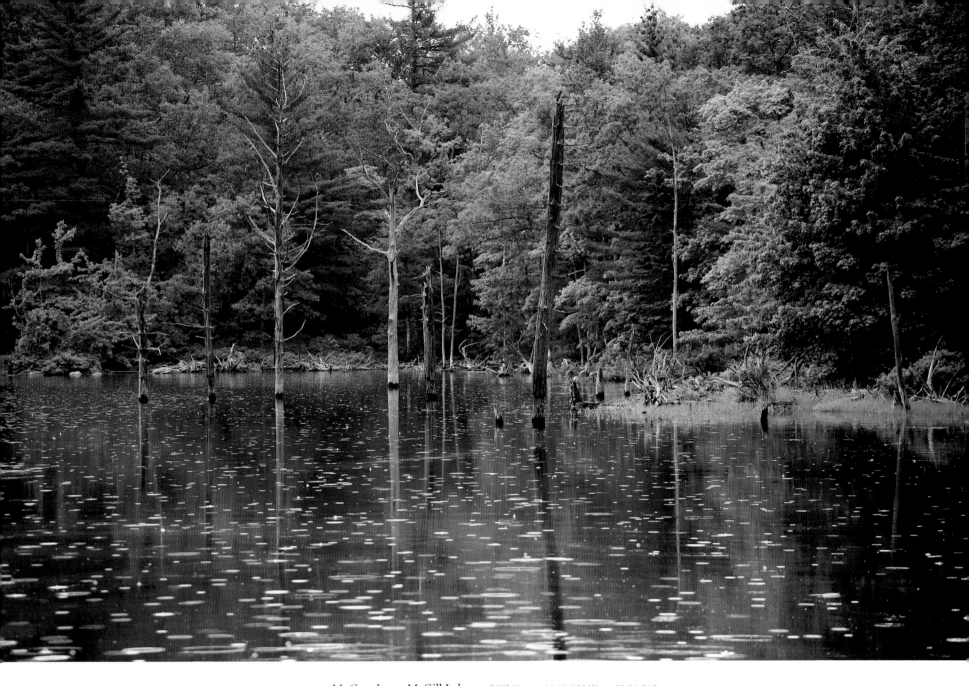

*McGill Lake*, McGill Lake — *(WA)* *North 44 40.582 West 65 01.042*

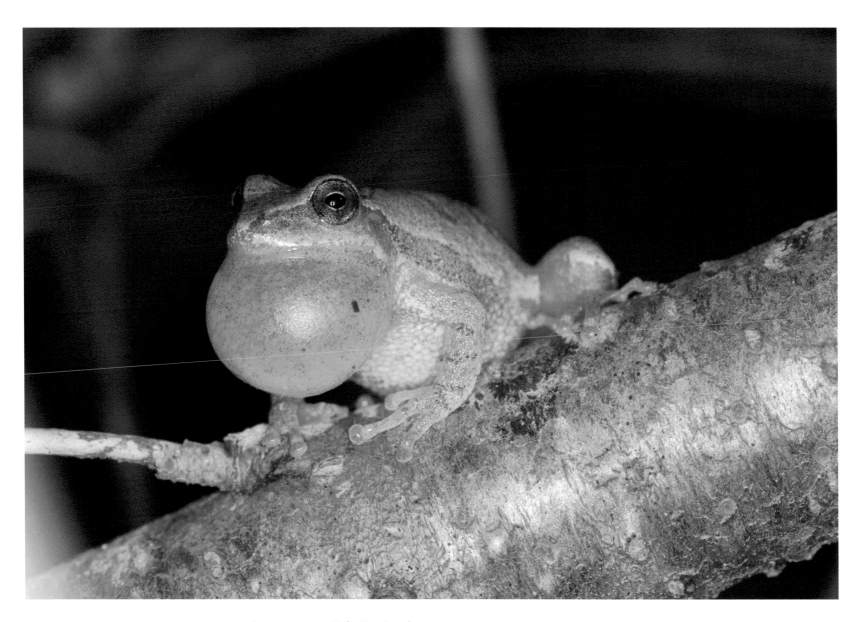

**Spring peeper**, Lake Rossignol — *(WA) North 44 16.441 West 65 05.136*

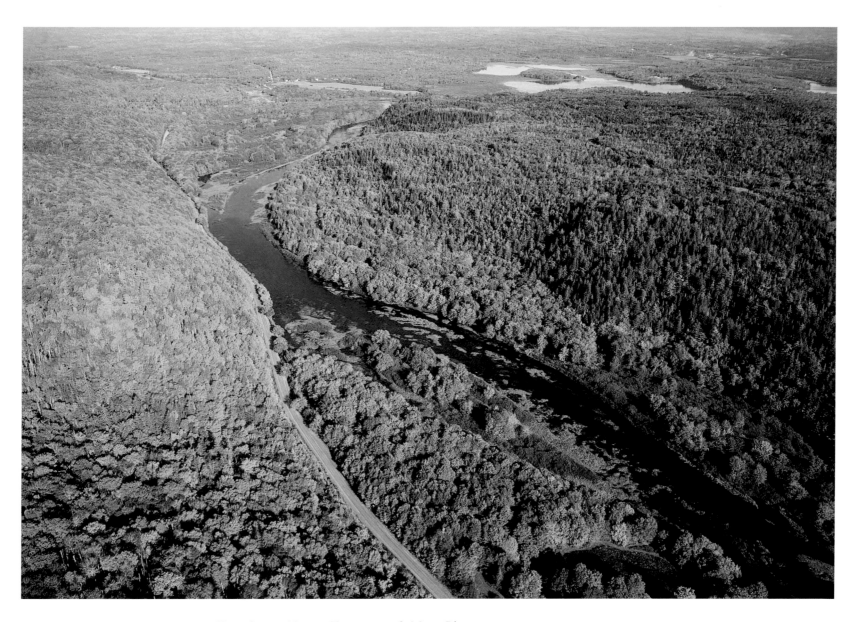

*Nova Scotia Nature Trust land*, St Marys River — *North 45 13.991 West 62 02.583*

Juniper needles, Clattenburgh Brook — *(WA) North 44 53.516 West 63 22.995*

*Wild Nova Scotia*

*Morning reflection on Kejimkujik Lake*, Kejimkujik National Park and Historic Site — *North 44 23.522 West 65 14.064*

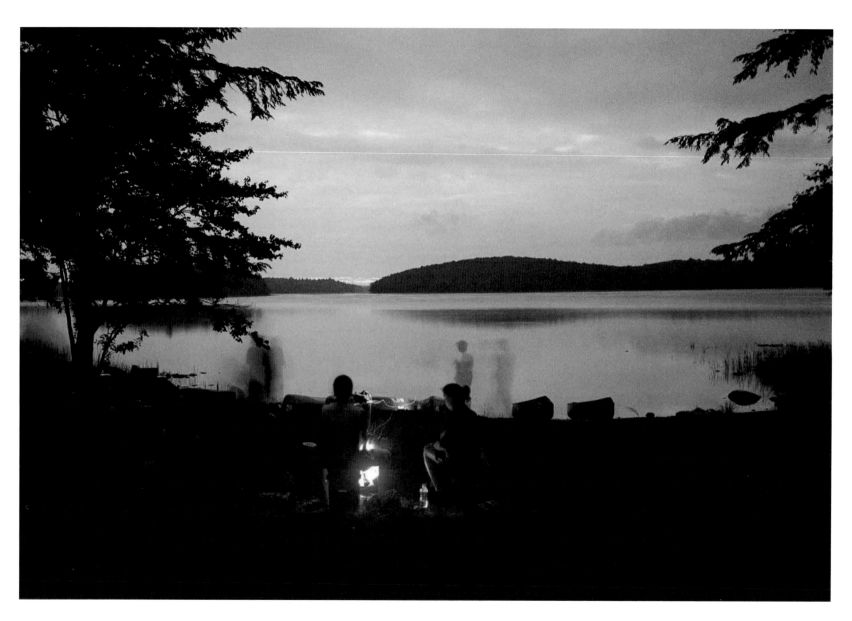

*RITCHIE ISLAND CAMPFIRE*, Kejimkujik National Park and Historic Site — *NORTH 44 23.379 WEST 65 14.337*

*Wild Nova Scotia*

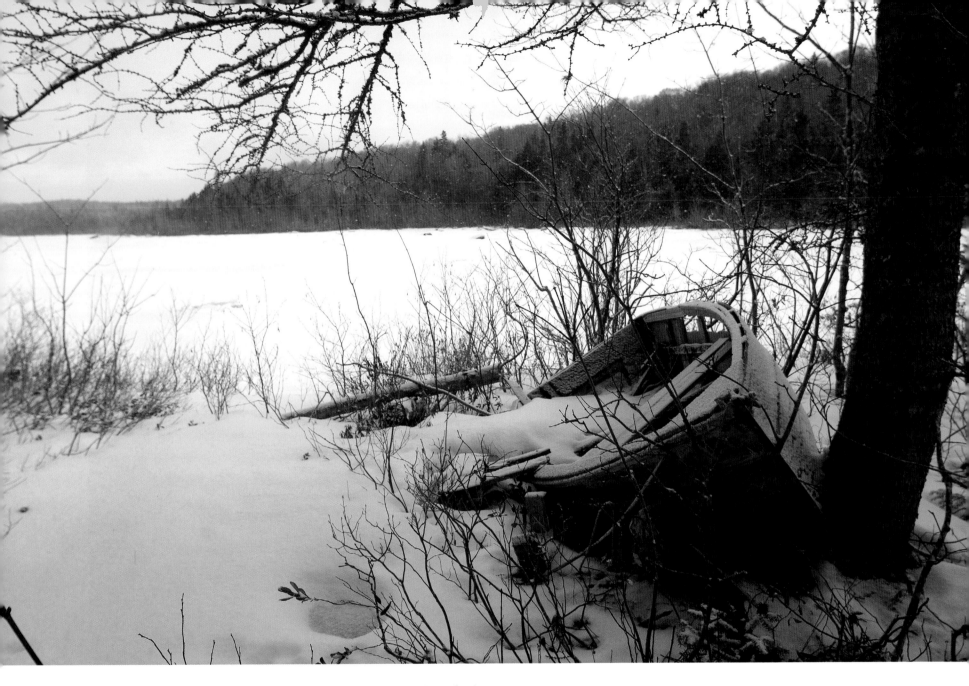

*Snow-swept shore*, Liscomb River — *(WA) North 45 02.634 West 62 06.623*

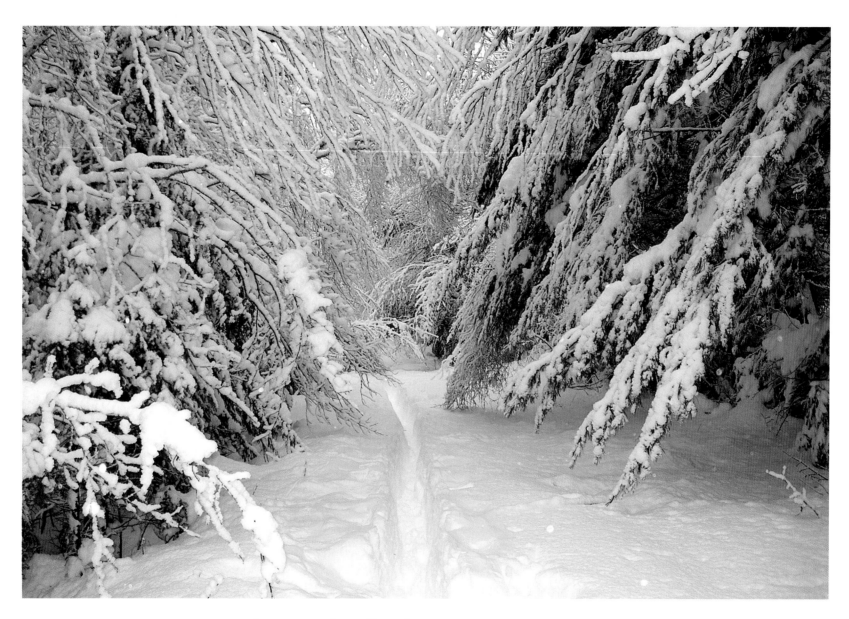

*Snowy woods*, Lower Sixty Lake — *North 44 43.345 West 64 48.388*

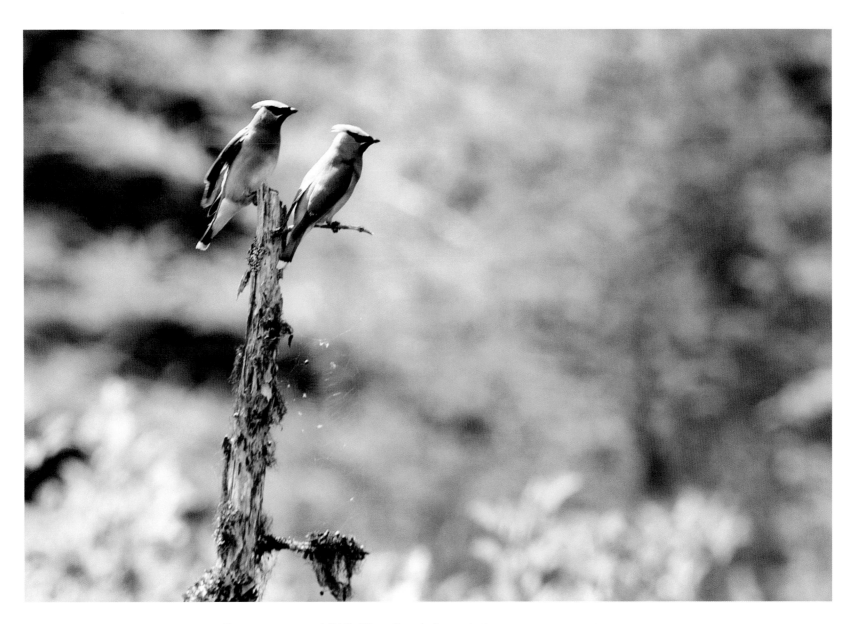

*Cedar waxwings*, Middle River–Framboise — *(WA) North 45 45.401 West 60 32.102*

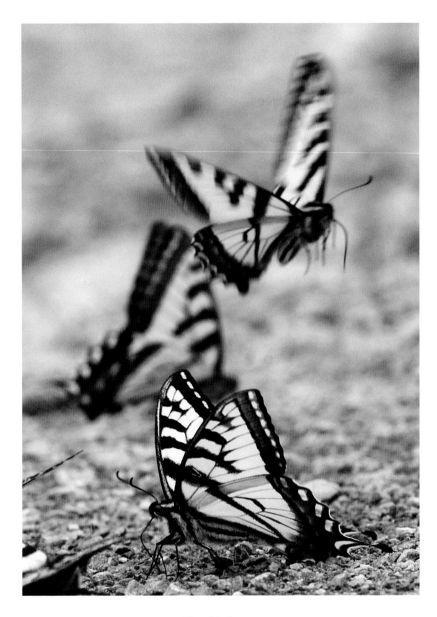

CANADIAN TIGER SWALLOWTAIL, Cloud Lake — *(WA) NORTH 44 52.046 WEST 64 53.848*

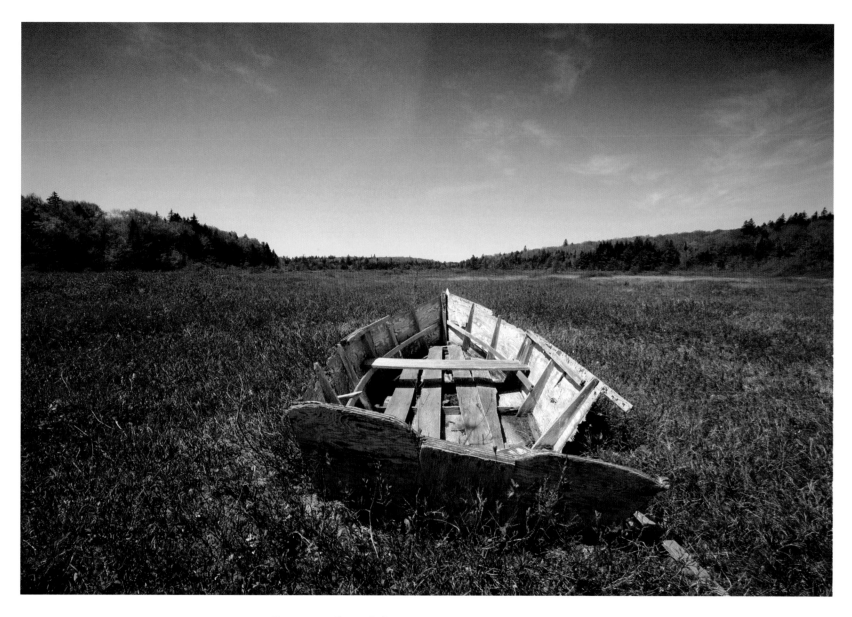

*Glory days*, Boggy Lake — *(WA) North 45 05.996 West 62 17.664*

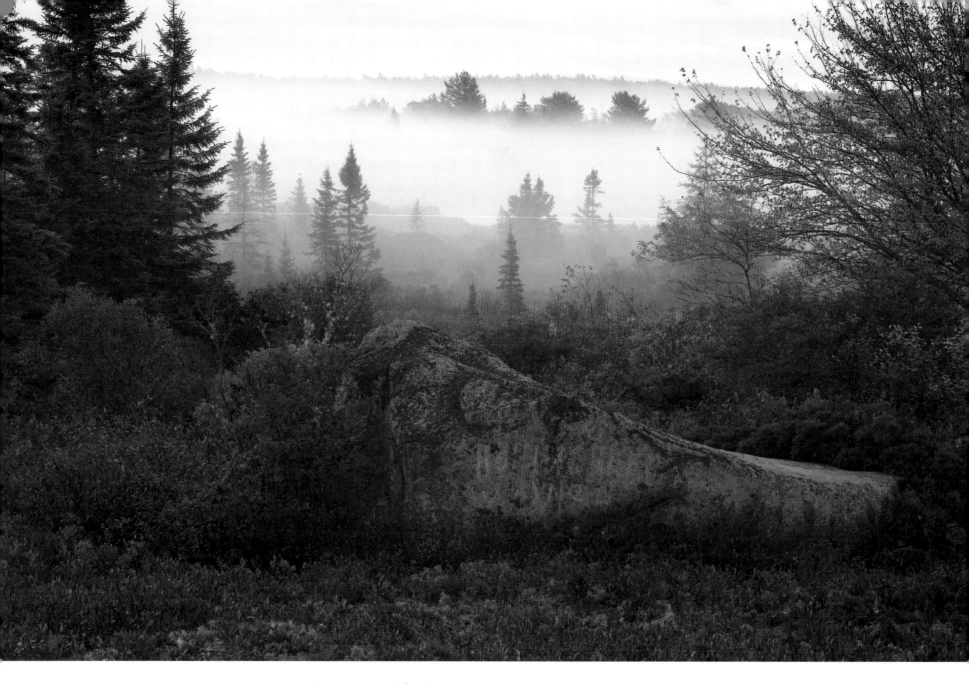

GRANITE MIST, Tobeatic — *(WA) NORTH 44 03.760 WEST 65 26.720*

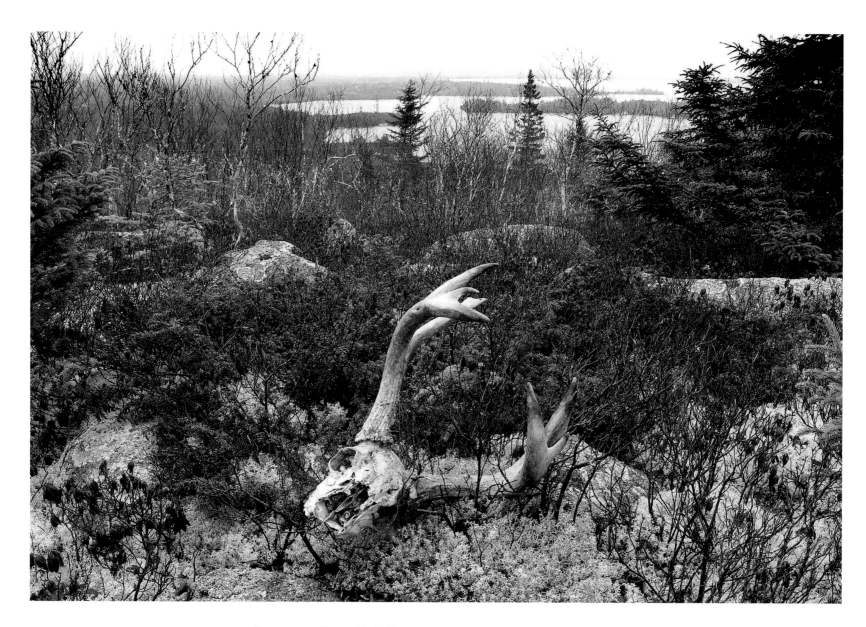

*Deer skull*, Bonnet Lake Barrens — *(WA) North 45 16.771 West 61 25.733*

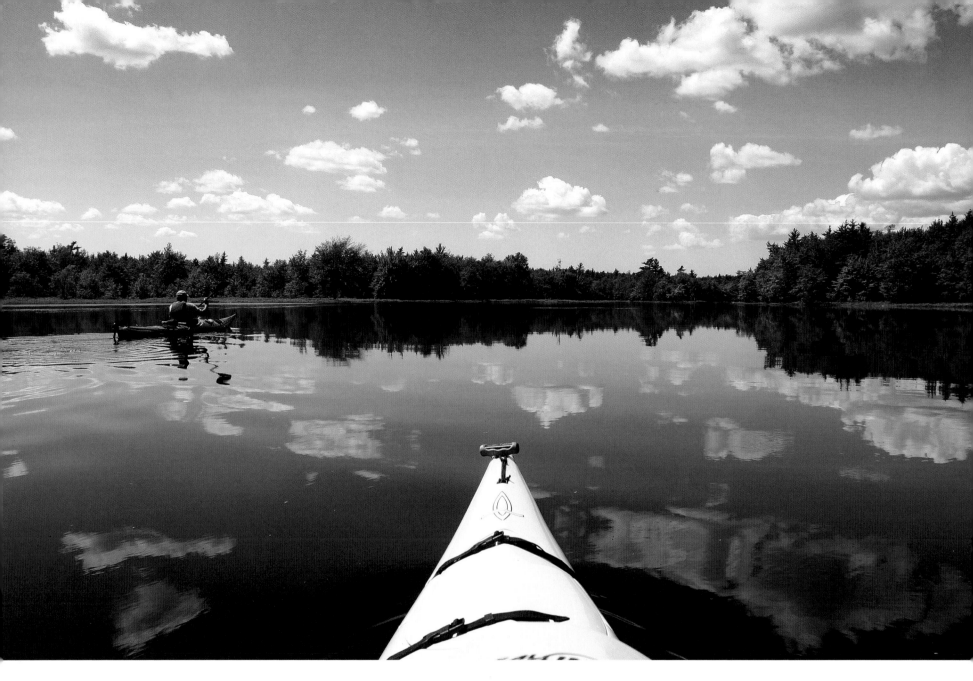

*Upstream paddle,* Shelburne River — *(CHR) North 44 12.635 West 65 13.356*

*Wild Nova Scotia*

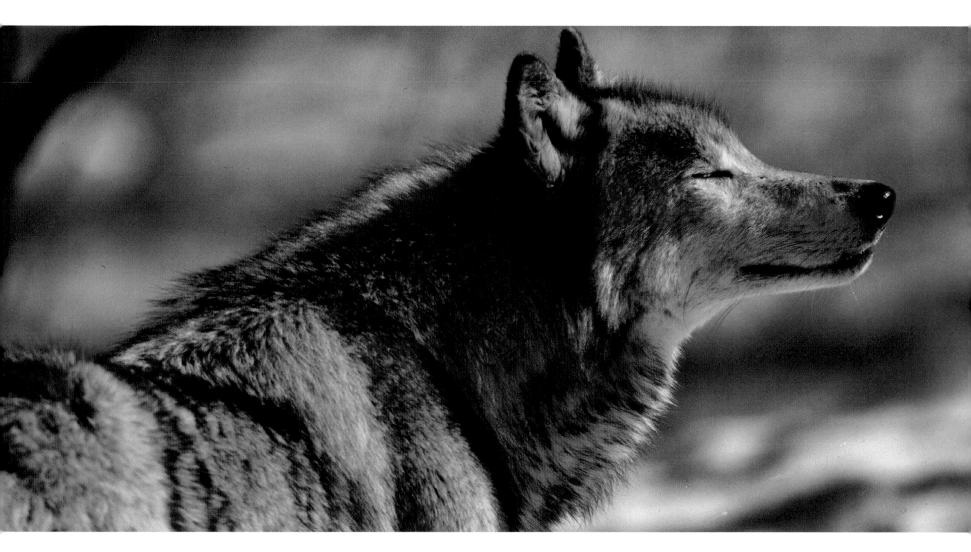

*Grey wolf*, Canadian Centre for Wolf Research — *North 45 05.555 West 63 23.539*

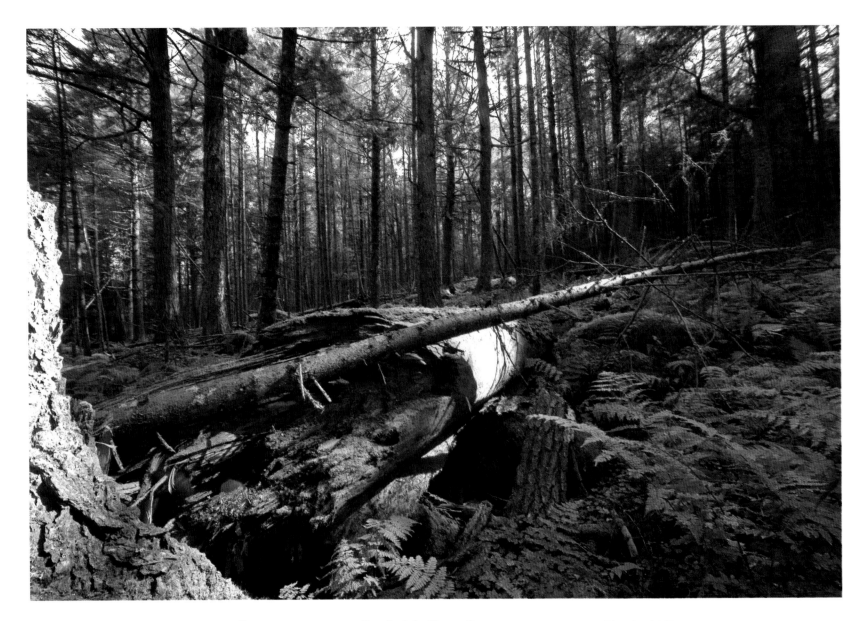

**ABOVE** || *OLD GROWTH FOREST*, Panuke Lake Nature Reserve — *NORTH 44 79.578 WEST 64 10.893*

**OVERLEAF** || *DAWN OVER ROSEWAY RIVER*, Tobeatic — *(WA) NORTH 44 03.115 WEST 65 27.813*

*Wild Nova Scotia*

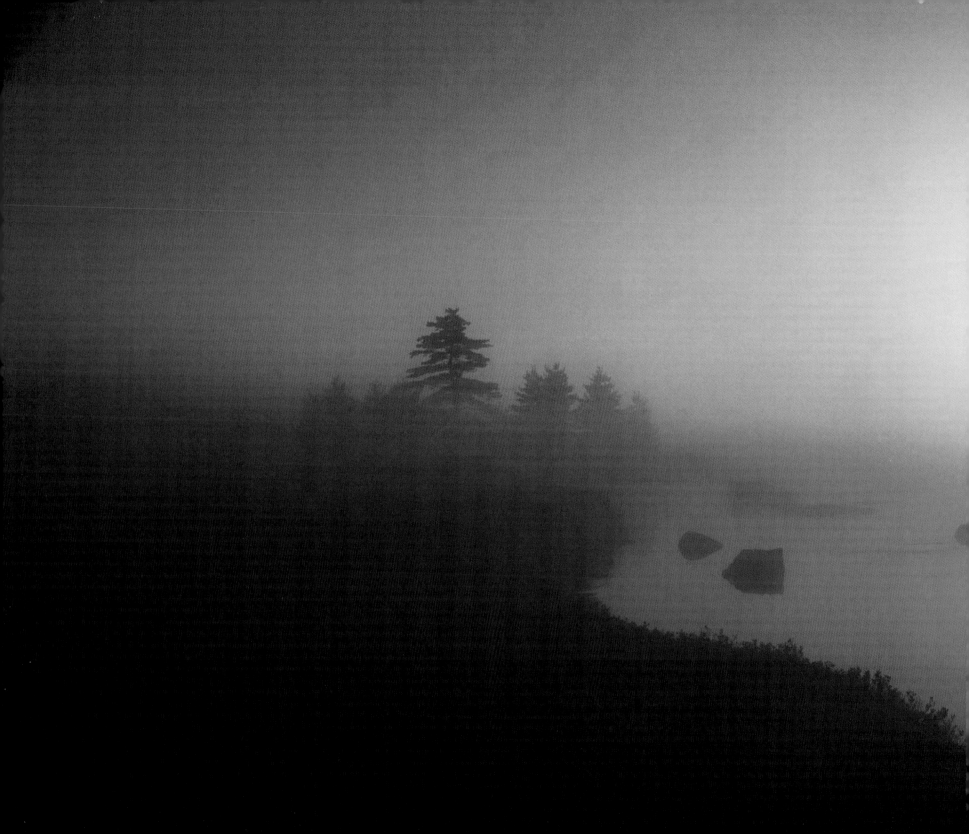

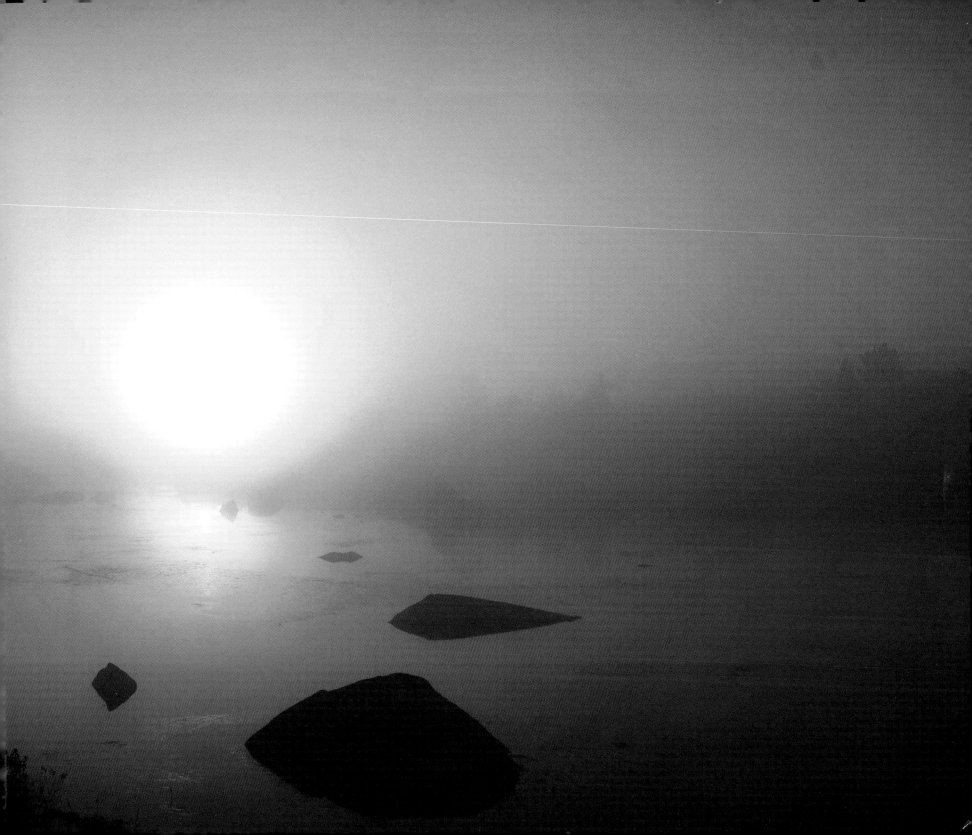

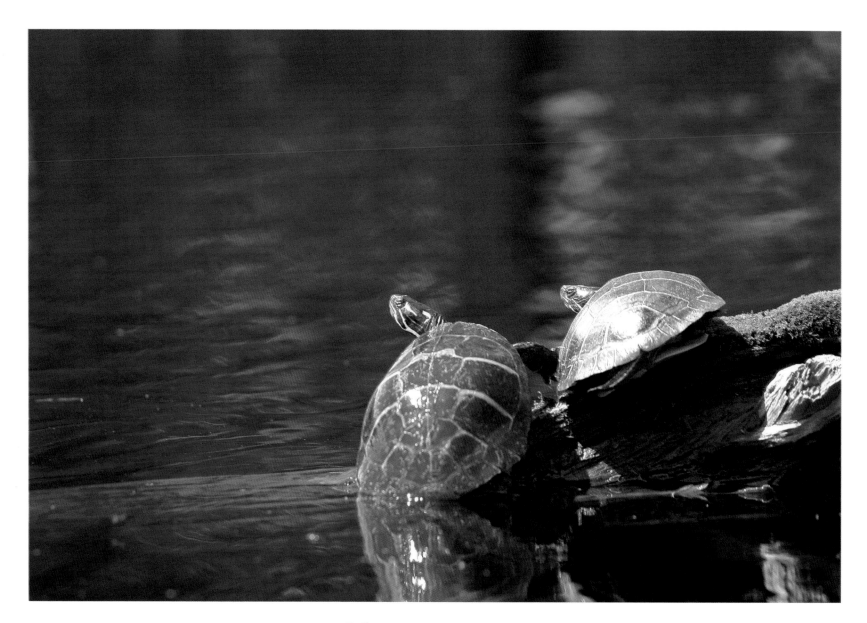

*Painted turtles*, Shelburne River — *(CHR) North 44 12.531 West 65 13.995*